Historic Tales from
PALOS VERDES
=== *and the* ===
SOUTH BAY

Historic Tales from
PALOS VERDES
and the
SOUTH BAY

Bruce & Maureen
MEGOWAN

Charleston London

THE
History
PRESS

Published by The History Press
Charleston, SC 29403
www.historypress.net

Copyright © 2014 by Bruce L. Megowan and Maureen D. Megowan
All rights reserved

Photos taken by and courtesy of Bruce L. Megowan unless otherwise noted.

First published 2014

Manufactured in the United States

ISBN 978.1.62619.607.0

Library of Congress CIP data applied for.

CONTENTS

Contents

PREFACE

In 2003, we decided to create a website for Maureen's business as a Realtor for the Palos Verdes Peninsula and South Bay beach communities. As part of this process, we wanted to include the history of the cities within which we worked. As we researched this, we were amazed to find that there was no online resource for the history of the Palos Verdes Peninsula, other than some collections of historical photos.

The more research we did, the more fascinated we became about the exciting history of the South Bay of Los Angeles and the Palos Verdes Peninsula. The more we dug into the historical archives of the Palos Verdes Public Library local resource room, the more we wanted to know. Our local history became a passion for us. The results of this can be seen in this book, as well as on our local history web page (http://www.southbayhistory.com) and on our website (http://www. maureenmegowan.com).

At the beginning of 2011, Warren Dow, publisher of *South Bay Digs* magazine, suggested that we write a biweekly history article for his magazine as part of our ad placement. He believed that this would demonstrate our unique local knowledge of our market, as well as our love and appreciation for what makes the Palos Verdes Peninsula and the South Bay such wonderful places to live. Thus began our article series entitled "South Bay History Tid-Bits." This book is a compilation of those articles.

We have lived in the South Bay for forty years, beginning in Manhattan Beach and Redondo Beach, and we have raised three children while living

in the Lunada Bay area of Palos Verdes Estates for thirty years. Many of the subjects of the articles included in this book came about simply by our driving around the South Bay and the Palos Verdes Peninsula, seeing interesting things and wondering about their history or the explanations for their existence. Our love for the area has been enhanced by learning the fascinating history of our beautiful community, and we hope that you have the same reaction while reading our book.

ACKNOWLEDGEMENTS

The authors would like to recognize the valuable assistance the following wonderful people gave us in compiling the information and many of the photographs used in this book: Don Christy (son of Suzanne Vanderlip and stepson of John Vanderlip); Vicki Mack; Warren Dow (publisher of *South Bay Digs* magazine); Daniel Pinkam (owner of the Portuguese Bend Gatehouse); Kelvin Vanderlip Jr.; Narcissa Vanderlip; the volunteer docents in the local history room of the Palos Verdes Public Library, particularly Marjene Blinn, Dotty Agronick and Therese Anlauf; Monique Sugimoto of the Palos Verdes Public Library staff; Marilyn Ron of the Antique Attic in Torrance; Steve Meisenholder of the Manhattan Beach Historical Society; Jan Dennis; and Gail Fornasiere of the Catalina Island Museum.

PALOS VERDES
HISTORY TALES

Palos Verdes's Early American Indian Inhabitants

While first described in 1542 by Portuguese explorer Juan Cabrillo, for almost three centuries the Palos Verdes Peninsula remained undisturbed and the exclusive domain of the local Indians, whose artifacts are still being unearthed. One of the richest treasure-troves found in Palos Verdes, archaeologically speaking, bordered Torrance on a bluff overlooking Malaga Cove. The University of Southern California (USC) and the Southwest Museum excavated the area in 1936 and 1937 and found thousands of artifacts. Eventually, archaeologists used radiocarbon dating and found that the Malaga Cove site had been inhabited by humans for at least 7,100 years. The early inhabitants found so much game, seafood and wild plants in the area that they never needed to develop farming.

The most recent Native Americans to live in Palos Verdes were members of the Tongva tribe, who spoke a Shoshone language. Most recently—between 1,000 and 235 years ago—a group called the Chowignas lived in Malaga Cove and at other sites in Palos Verdes. Chowigna villages stretched from the South Bay to Catalina Island. The biggest village in the area, though, was believed to be at Machado Lake, between Gaffey Street and the 110 Freeway. It was called Suang Na.

The Tongvas did not use a written language, but their myths and superb knowledge of their environment were passed down from one generation to

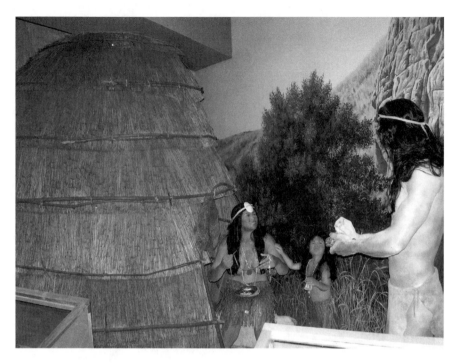

Tongva Village as seen at the Palos Verdes Interpretive Center. *Photo by Bruce Megowan.*

the next through storytelling and teaching. Large trees did not grow in this part of California, so they built houses with frames made of willow poles. They also constructed reed boats and sealed them with tar or asphalt found on the beach. The Spaniards called the native people after the names of nearby missions. The natives in the Los Angeles area became known as the Gabrielinos, because they were the closest to the Mission San Gabriel.

During the summers, the Tongvas camped along the ocean and hunted in places such as Abalone Cove for fish, seals, sea otters, abalone and other shellfish using their canoes. During the cold, rainy season, they moved back to base camps on higher ground and hunted deer, rabbits and squirrels.

For more than two hundred years after the first explorers came, the Spaniards occasionally met and traded with the Tongva people. In the late 1700s, the Spaniards began to permanently settle the Palos Verdes Peninsula area. As they moved in with their cattle, horses and new crops, the native animals and plants on which the Tongvas relied for their survival began to disappear. The Spanish began to persuade the Americans Indians to give up their old way of life and move to the Spanish

missions and ranchos, where they would learn farming and cattle raising. The Spanish missions interrupted life for the Chowignas. At the Malaga Cove site, the most recent artifacts found nearest the surface were glass beads that the Spanish brought. An estimated 150 people lived at the site in its last days, in about 1775.

Bixby Ranch

In 1882, the Rancho de los Palos Verdes land grant, once owned by the Sepulveda family, was partitioned into seventeen parcels as part of a complex legal settlement. The largest share, sixteen thousand acres, which included most of the Palos Verdes Peninsula, went to rancher Jotham Bixby. Bixby built his ranch house near where the Peninsula Center and Avenue of the Peninsula shopping centers currently stand.

In 1894, Jotham Bixby's son George hired Harry Phillips Sr. to manage the ranch. Phillips built and occupied the first permanent residence on the Palos Verdes Peninsula in 1894, a small cottage near the present Rolling Hills City Hall. It was replaced in 1910 by a larger farmstead called "the farmery," which was built in Blackwater Canyon on the current-day Lariat Lane just southeast of the intersection of Palos Verdes Drive North and Rolling Hills Road, where the family lived until the late 1920s. Harry, an Englishman, came to the Palos Verdes Peninsula in 1887, settling in San Pedro. The Peninsula, covered with chaparral, had almost no trees, and water was scarce.

Harry was responsible for planting the first groves of eucalyptus and Pepper Trees in the city of Rolling Hills Estates. Phillips also was responsible for planting for firewood the extensive groves of eucalyptus and pepper trees in what is now the Valmonte area of Palos Verdes Estates. He brought agriculture to the region. He upgraded the Bixby cattle by introducing thoroughbred Hereford bulls and marketed the beef to a growing, hungry Los Angeles; he had a herd of nearly two thousand head of cattle.

Harry farmed large areas of hay and barley, as well as lima beans and other dry farming crops. He encouraged Bixby to lease coastal portions of the ranch near Portuguese Bend to Japanese farmers for ten dollars per an acre. About forty families took him up on the offer, including longtime South Bay farmers the Ishibashi family. They raised a variety of vegetables, particularly tomatoes and peas.

Henry Phillips Jr. and John "Jack" Phillips, the latter the first son of Harry Phillips Sr., built their own ranch houses in the early 1910s located near the east end of the area that became the Palos Verdes Golf Course in the Valmonte area of Palos Verdes Estates. Another early ranch was built at about the same time in the same area by Raymond McCarrell and was known as the McCarrell Ranch.

The Bixby Ranch was sold in 1913 to New York banker Frank A. Vanderlip Sr., who ultimately developed the Peninsula. Phillips continued to run the ranch until 1920. Two years later, he died of cancer in Lomita at age fifty-nine, according to his grandson, Harry Phillips III.

Palos Verdes Estates History

The Palos Verdes Project

Early in 1913, George Bixby decided to sell about sixteen thousand acres of the Rancho de los Palos Verdes (retaining about one thousand acres that later became Harbor City), which his father, Jotham Bixby, had acquired in 1882 by a legal partition of the original land grant area of Rancho de los Palos Verdes. He sold the land to Walter Fundenburg, who agreed to pay $1.8 million. Unable to raise the necessary funds, Bixby assigned the property to the real estate firm Schader and Adams. It, too, was unable to raise the necessary capital, and Bixby foreclosed on the mortgage. After much litigation, Bixby agreed to allow Schader and Adams ninety days to complete the purchase. Mr. Carl Schader then left for New York to raise the money, with about twenty days left to raise the funds. While there, he was able to get Mr. Frank A. Vanderlip, then president of the National City Bank of New York, interested in the property. Although Mr. Vanderlip had never seen the property, after only a ten-minute meeting with Mr. Schader he was intrigued and recognized its potential for development.

By November 1913, Mr. Vanderlip had organized a consortium of New York investors and completed the purchase of the property. Historical accounts of the final purchase price range from $1.5 million to about $2.4 million. Initially, these investors intended to divide the land into large estates.

The founding father of the Peninsula, Mr. Vanderlip, was one of these investors. Mr. Vanderlip was a self-made man, an assistant secretary of

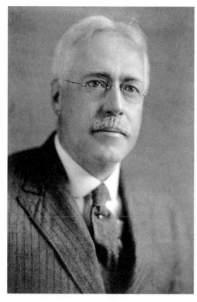

Left: A 1917 photo of Frank A. Vanderlip Sr. *Courtesy Library of Congress.*

Middle: Sketch of proposed Los Palos Verdes Country Club in Portuguese Bend by architects Howard Shaw and Myron Hunt. *Courtesy Don Christy Collection.*

Bottom: View of South Bay coastline from Malaga Cove. *Photo by Bruce Megowan.*

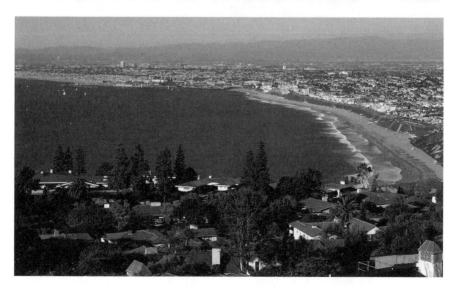

the treasury under President McKinley (1897–1901) and president of the National City Bank of New York. He started at the bank in 1902, becoming president in 1911 (through 1919) at the age of forty-five. Frank was one of the financial leaders of the early twentieth century and was instrumental in the passage of the Federal Reserve Act in 1913.

The syndicate that Mr. Vanderlip formed to finance the purchase of the Palos Verdes Ranch consisted of more than fifty wealthy men, including Harry P. Davidson of J.P. Morgan and Company; Benjamin Strong, president of the Bankers' Trust Company of New York; and Frank Trumbull, chairman of the board of the Chesapeake and Ohio Railroad.

From the beginning, Mr. Vanderlip had great plans for the development of the property. As early as 1914, Mr. Vanderlip hired architects, including the landscape architectural firm of Olmsted Brothers, to draw up a master plan for the development. Original plans included the construction of a magnificent golf club on the bluffs overlooking Portuguese Bend to be known as "Los Palos Verdes Country Club."

Mr. Vanderlip planned to develop the area above Point Vicente lighthouse as an Italian hillside village, to be occupied by craftsmen who would live and work there and sell their wares.

Mr. Vanderlip wrote glowingly in his biography about a visit in 1916 to the Palos Verdes Peninsula and the property he had bought unseen three years earlier. He described his vision for the development, likening the geographical location to Italy, where he took vacations:

> *I found myself reminded vividly of the Sorrentine Peninsula and the Amalfi Drive: Yet the most exciting part of my vision was that this gorgeous scene was not a piece of Italy at all but was here in America, an unspoiled sheet of paper to be written on with loving care.*

Was the Original Palos Verdes Developer a Crook?

After Frank Vanderlip had acquired about sixteen thousand acres of the Rancho de los Palos Verdes in 1913, he made grand plans to develop the Palos Verdes Peninsula. However, World War I curtailed these plans. In 1919, a syndicate led by Irving Hellman acquired an option from Mr. Vanderlip to purchase the entire Palos Verdes Peninsula for $3.2 million. Hellman's plans were to drill for oil and then to subdivide the balance of the land for homesites. These plans were later abandoned.

In 1921, a real estate developer named Edward Gardner Lewis acquired an option to purchase the entire 16,000 acres for $5 million. His first planned acquisition was the Palos Verdes Project, which would constitute the future city of Palos Verdes Estates and part of the Miraleste area of the current-day city of Rancho Palos Verdes. The community was called Palos Verdes Estates and consisted of 3,225 acres.

By the time Mr. Lewis arrived in Palos Verdes, he already had made and lost a fortune as a mail-order magazine publisher, founder of a bank-by-mail service and builder of a vegetable-dehydration plant. He also dabbled in high-risk mining and oil ventures. In 1899, he

E.G. Lewis in 1925. *From the* Lewis Journal *newspaper, Palos Verdes Public Library District Local History Room.*

purchased a magazine called *The Winner*, based in downtown St. Louis, and renamed it *Woman's Magazine*. He quickly built its circulation to the largest in the country, amassing a fortune in the process. Many believe that Mr. Lewis was a leader in the women's suffragette movement; however, others believe that he promoted the movement only to increase the number of subscribers to his magazine. In 1907, Mr. Lewis founded the American Women's League (AWL) as a way to spread the tenets of women's suffrage, as well as gain new salespersons for his magazine business.

Mr. Lewis was an entrepreneur and a visionary and was the founding father of two model cities, University City in Missouri (founded by Mr. Lewis in 1904 in conjunction with the 1904 World's Fair) and Atascadero, California (founded as a utopian colony by Mr. Lewis in 1913). To this day, the Colony Days celebration is held in Atascadero every year honoring Mr. Lewis, and he is also held in high esteem and remembrance by the citizens of University City as that city's founding father.

Mr. Lewis had plans to raise $35 million to develop the Palos Verdes property by syndicating interests to investors. He sold two types of investments: a convertible subscription redeemable for land and a

nonconvertible subscription in trust indenture notes investing directly in the Palos Verdes Project. Mr. Lewis, however, had been accused of fraud in several previous investment schemes, including oil wells, almond tree farming and a magazine. On March 30, 1922, the *Los Angeles Examiner* published a telegram it had received:

> *Suggest you investigate E.G. Lewis before running any more of his adds [sic] if you honestly wish to protect your readers. In one set of circulars he holds out gigantic promises and in another set he sidesteps past due obligations to his thousands of old oil investors. In my opinion he is paying for his big Palos Verdes advertising campaign with money diverted from investments in his huge unsuccessful doodlebug oil promotion in Montana.*

The cable was signed "J.E. McDonald." This man's history with Lewis was unclear, but he appeared to be a previous victim. After Lewis's schemes for the trust indenture notes met with distrust by the Title Insurance and Trust Company of Los Angeles in February 1923, Mr. Vanderlip stepped back in; a new real estate trust called Commonwealth Trust, financed by some four thousand investors, was created, and by 1924, control of the project was back in the hands of the original Vanderlip syndicate.

Although Mr. Lewis was only involved in the Palos Verdes Project for about three years, his legacy is important as he advanced many of Mr. Vanderlip's original plans for the project.

Mr. Lewis was sued for $20 million by previous investors, and in 1925, he declared bankruptcy. In 1927, he was sentenced to six years in federal prison. He was paroled in 1931 but was sent back to prison for violating parole. Released again in 1935, he returned to Atascadero, where he spent the rest of his life as a penniless recluse and died in 1950.

Palos Verdes Estates: The Master Planned Community

The master plan for the Palos Verdes Project was originally drafted by Charles Cheney of the architectural firm Olmsted Brothers. Cheney arrived on the scene in about 1921, brought in by the then-developer of the Palos Verdes Project, Edward G. Lewis, with whom he developed Atascadero in 1913. Cheney was a leader in city planning. He was director of the National Conference on City Planning and had experience in many other California cities. The father of the Olmsted brothers

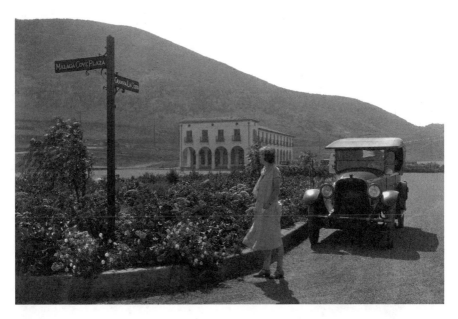

This image shows a view looking southwest of the east and north façades of the Gardner Building (La Casa Primera). Visible in foreground is a woman standing near the newly planted landscaping and a signpost with street signs for "MALAGA COVE PLAZA" and "GRANVIA LA COSTA"—streets later renamed Via Chico and Palos Verdes Drive West. *Courtesy Palos Verdes Library District Local History Collection*

designed Central Park in New York. The Olmsted brothers designed the street layout of the city of Torrance.

Planning for the project covered all aspects, including the street system, zoning, lot sizes and planned landscaping. Frederick Law Olmsted Jr., in a 1923 report, explained landscape design for the northern entrance to Palos Verdes Estates:

> *I advise against a large plaza or any other marked demonstration at the property line where it would be liable to be spoiled by developments in contact with it outside the property. I think the most effective treatment at the entrance will be to plunge directly into the wood of Eucalyptus through an opening as narrow as would be practicable and dignified (since the flanking masses are not tall enough to be impressive if the opening is very wide) and after passing through this sylvan gateway for a considerable distance then widen out into an impressive demonstration where the view of the valley and hills and sea can burst upon one.*

Architect's rendering of proposed Valmonte Plaza. "OLMSTED BROTHERS—DIRECTORS OF DESIGN / CHARLES H. CHENEY" and "MARSTON, VAN PELT & MAYBURY—ARCHITECTS." *Courtesy Palos Verdes Library District Local History Collection.*

After Frank Vanderlip retook control of the project from E.G. Lewis in 1923, he continued to direct Mr. Cheney in planning the Palos Verdes Project.

The original master plan envisioned three major business centers in Malaga Cove, Valmonte and Lunada Bay, with minor business centers in Margate, Miraleste and Montemalaga; however, only those in Malaga Cove, Lunada Bay and Miraleste were constructed.

In addition to the early planned districts of Valmonte, Malaga Cove, Margate, Lunada Bay and Miraleste, there were several other planned districts, now part of Rancho Palos Verdes: Telarana (near the Point Vicente lighthouse), Taravel (near Long Point), Cabrillo (near Portuguese Bend) and Altamira (near the Peninsula Center shopping center). A very large diorama, measuring twenty-five by thirty-eight feet, was constructed and displayed in the downtown Los Angeles sales offices of the Palos Verdes Project.

The original master plan was one of the best examples of urban planning of its day and included architectural restrictions to maintain

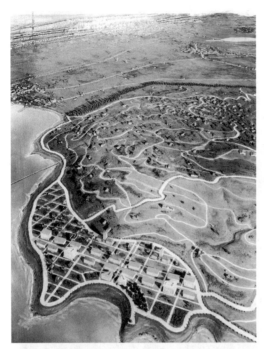

Left: Palos Verdes Project Diorama of Lunada Bay area. *Courtesy Palos Verdes Library District Local History Collection.*

Below: Palos Verdes Project Diorama of Portuguese Bend area. Note the planned breakwater and major commercial center where the Trump National Golf Course is now located. This image came from an early 1920s newsprint solicitation for subscriptions to the Palos Verdes Project indentures. *Courtesy Palos Verdes Library District Local History Room.*

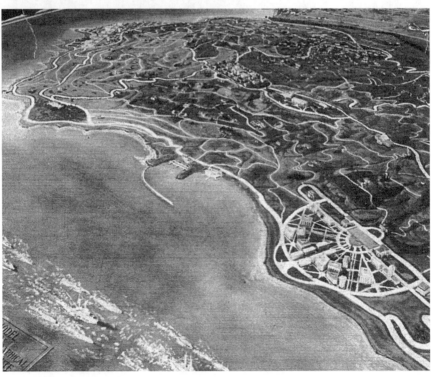

the Mediterranean design of the project. These deed restrictions, now enforced by the Palos Verdes Art Jury, are still in effect in Palos Verdes Estates and the Miraleste area of Rancho Palos Verdes.

Original Development Plans for Palos Verdes Project

The original development plans for the Palos Verdes Project proposed by Frank Vanderlip and E.G. Lewis, the developer brought in by Mr. Vanderlip in the early 1920s, included a number of very exciting proposals that were never implemented.

A breakwater was proposed in Lunada Bay that would have created a sandy swimming beach. A clubhouse was proposed to accommodate bathing and beach parties.

The construction of a marina and yacht club at Bluff Cove around the corner from Malaga Cove would have included a grand clubhouse building at the top of the cove, as well as a yachting marina. The Pacific Coast Yacht Club was formed in 1927 to construct the marina and planned to enclose some sixty-six acres of water and provide moorings for four hundred craft.

A plaza area was proposed to be built in the Valmonte area at the intersection of Via Campesina and Palos Verdes Drive North, in addition to Malaga Cove Plaza and Lunada Bay Plaza, which were constructed. The original plans called for the Lunada Bay Plaza to be constructed on Avenida Mirola, a few streets to the south of the current location of the plaza on Yarmouth Road. The original plans called for a grand Italian shopping plaza with a tower.

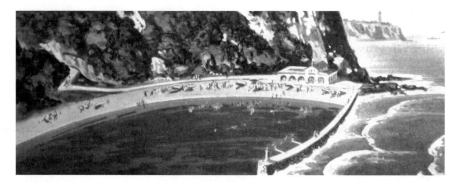

Proposed Lunada Bay breakwater. This image came from a promotional brochure for the Palos Verdes Project. *Courtesy Palos Verdes Library District Local History Collection.*

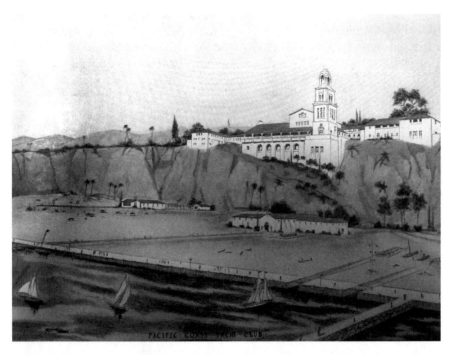

Proposed Pacific Coast Yacht Club at Bluff Cove. This image came from *The Palos Verdes of Today—1926*, a promotional brochure for the Palos Verdes Project. *Courtesy Palos Verdes Library District Local History Collection.*

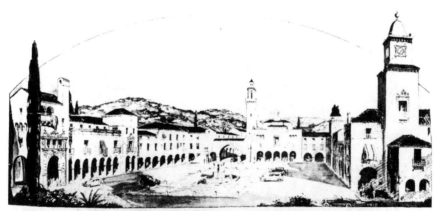

Original proposed design for Lunada Bay Plaza. This image came from a promotional brochure for the Palos Verdes Project. *Courtesy Palos Verdes Library District Local History Collection.*

E.G. Lewis had proposed the construction of a monorail running from downtown Los Angeles to the Palos Verdes Peninsula, with a spur line to the San Pedro Harbor. A breakwater, marina and beach club were proposed for the Portuguese Bend area.

These grandiose plans were primarily dashed by the Great Depression, but fortunately much of the carefully laid-out plans for the development of Palos Verdes survived and were implemented.

Frederick Olmsted Jr. and Charles Cheney

Born in 1870, Frederick Law Olmsted Jr. was the son of the Central Park architect Frederick Law Olmsted. He took over the firm together with his stepbrother, John Charles Olmsted, when his father died in 1895, renaming it Olmsted Brothers. Frederick had a substantial impact on the planning of the South Bay in two distinct ways.

The original developer of the city of Torrance, Jared Sydney Torrance, engaged Frederick Olmsted to create a master plan of the city in 1911. Olmsted's overall Torrance plan was innovative for its time. It divided the original town into three districts: the business district at the city's core, which we know now as Old Torrance; the industrial district to the north and east of the city core; and the residential district to the west.

Perhaps Frederick's most influential impact, though, was in his firm's groundbreaking landscape design for the city of Palos Verdes Estates. It laid out Palos Verdes Estates' roadways and prepared the landscape design for Malaga Cove Library, Malaga Cove School and the La Venta Inn. More than ten thousand trees and shrubs were planted during the early days of development. To promote landscaping by the new homeowners, a large nursery was created in Lunada Bay to sell plants at cost. Mr. Olmsted also decided to make the Peninsula his permanent home and became the first person in Palos Verdes to build directly on the edge of the bluffs on Rosita Place.

The most impressive part of his designs for Palos Verdes Estates was his design for the entrance to the city from Redondo Beach on Palos Verdes Drive. The sweeping flow of the drive into the city seems to bring the visitor into another world of lush landscaping and eucalyptus trees.

The resulting Malaga Cove Plaza and surrounding area remains one of the most beautiful urban locations in the South Bay to this day. In 2000, a small parcel of parkland was created in Olmsted's honor in the plaza and named Olmsted Place.

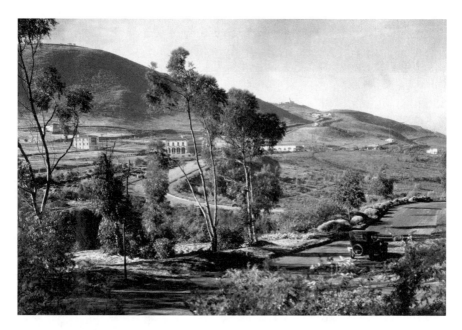

Entrance to Palos Verdes and Malaga Cove from Redondo Beach, 1925. *Courtesy Don Christy Collection.*

The overall master plan for Palos Verdes Estates was developed by Charles Henry Cheney, an architect and city planner. This was one of the earliest examples of a master-planned community. More than 120 miles of paved roads were drawn into the plans. More than four thousand acres were reserved for parks, playgrounds and recreational areas. Even one thousand acres were set aside for a university campus that was included in a proposal for the new University of California–Los Angeles (UCLA) campus. Mr. Cheney also developed the deed restrictions that still govern architectural standards in the city through its art jury. Mr. Cheney was a consultant to the city planning commissions for the cities of Fresno, Berkeley, Palo Alto, Turlock and San Rafael.

Malaga Cove Plaza

The original master plan for the Palos Verdes Project, which now includes the city of Palos Verdes Estates, envisioned several business centers, and Malaga Cove Plaza was the first of those constructed.

Most people assume that the Malaga Cove plaza buildings were all constructed at the same time. Actually, the buildings were constructed over a period of thirty-six years! The Original Conceptual Design of Malaga Cove Plaza was done by Webber, Stanton and Spaulding, Architects, which designed the first two buildings constructed in the mid-1920s.

Construction of the first commercial building in Malaga Cove began in 1924 and was completed in September 1925. The building, commonly referred to as the Gardiner Building, named after its owner, W.W. Gardiner, was also named Casa Primera by the Homes Association, in keeping with the Spanish theme of naming of streets, plazas and so on. The Gardiner Building was the site of the first classrooms in the community on the upper floor and had a grocery market, a post office, a library, an interior design shop and Bruce Drug Store on the first floor.

The second building constructed, completed in 1929, was built at the east end of the plaza and was known first as the Alpha Syndicate Building and later as Casa del Portal. This building included the archway constructed over Via Chico. The next building constructed on the plaza was not built until

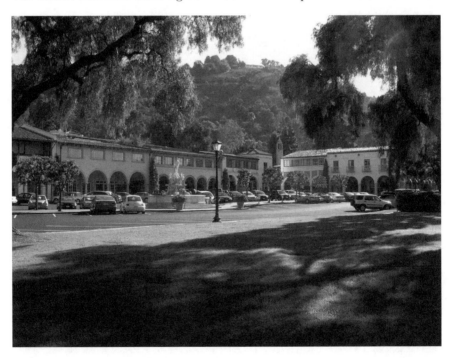

Malaga Cove Plaza. *Photo by Bruce Megowan.*

1950, next to the archway. The general store was then built at the far corner of the plaza in the early 1950s by Walter Davis and continues today as the Malaga Cove Market. The other three buildings between these two were constructed between 1957 and 1962, with the one built next to the market, known as the Barnett Building, originally constructed as a medical office building by Dr. McFarlane. The building next to the Gardiner Building, currently the location of the Malaga Cove office of RE/MAX Estate Properties, was not constructed until 1961 by Howard Towle.

One other significant landmark in Palos Verdes Estates is the Neptune fountain, located in the central plaza of Malaga Cove Plaza. This fountain—incorporating a statue of Neptune, the Roman god known as the King of the Sea—was installed in 1930. The fountain is a replica of the great bronze fountain of Neptune in Bologna, Italy, but it is only two-thirds the size of the original statue donated.

This marble replica was brought to the United States by art collector Aldopho diSegni. The replica was thought to be nearly one hundred years old and had been obtained from the courtyard of an old villa north of Venice. After almost forty years, the original statue finally crumbled and

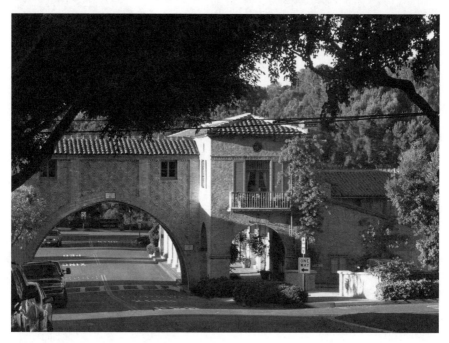

Archway for Casa del Portal building in Malaga Cove Plaza, constructed over Via Chico. *Photo By Bruce Megowan.*

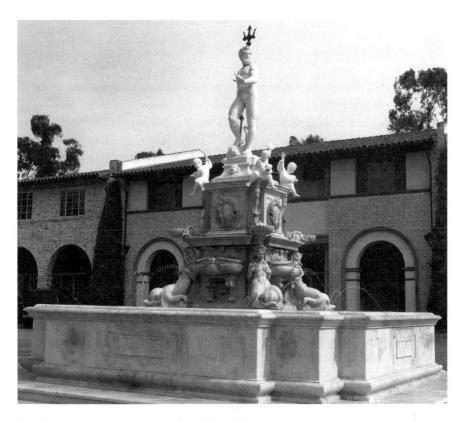

The Neptune fountain in Malaga Cove Plaza. *Photo by Bruce Megowan.*

was replaced in 1969 by a slightly smaller replica. Supposedly, the original city planner Cheney, after the original statue was installed in 1930, replied to a group of ladies who hinted shyly that they didn't like the fountain, undoubtedly because the mermaids on the pedestal were emitting water from their breasts, saying, "But ladies, we couldn't afford milk!"

Lunada Bay

Lunada Bay, a neighborhood on the west side of the Palos Verdes Peninsula in Palos Verdes Estates, was one of the early areas developed as part of the Palos Verdes Project.

It may be hard to envision today, with the extensive landscaping and groves of trees that currently exist on the Peninsula, but the Palos Verdes

Peninsula in the 1920s primarily consisted of coastal sagebrush, with very few trees. The Palos Verdes Project in the 1920s and 1930s employed a large number of gardeners who planted trees and plants. A very large nursery was constructed on the current site of Lunada Bay Plaza to grow plants to be used in the project.

The large median strip down the middle of Palos Verdes Drive West was planned to accommodate the expansion of the Red Car trolley line to the area. Original plans called for the construction of the Lunada Bay shopping plaza on Via Mirola, but it was later built on Yarmouth Road.

Original plans also envisioned several recreational facilities, which were never constructed. One of these, the proposed Pacific Coast Yacht Club, was to be a million-dollar enterprise backed by leading yachtsmen, to be housed in a palatial building south of Bluff Cove, and included a large marina. Another planned improvement was a breakwater to be constructed to form a swim cove at Lunada Bay.

The fountain in the median strip of Palos Verdes Drive West in Lunada Bay was a gift from funds raised by 250 neighborhood children organized by Jeane Burke, a resident of Rocky Point in Lunada Bay, and a plaque at the fountain displays the fountain's name, *Fuente de los Ninos* (*Fountain of the Children*).

The fountain is dedicated to G. Brooks Snelgrove, who was the original engineer for the Palos Verdes Project in 1923. The fountain was refurbished in December 2008, paid for by the generous donations of Lunada Bay residents.

One interesting event that occurred in 1961, one that people still talk about, was the running aground of the Greek freighter *Dominator* just off Rocky Point. The freighter was heading south along the Palos Verdes coastline; with the crew thinking that they had reached Los Angeles Harbor, they made an ill-fated left turn too early and ran aground. Only a small amount of remnants of the ship can still be seen at low tide.

A large landslide occurred during the El Niño winter of 1982–83 above Bluff Cove on Palos Verdes Drive West that caused two homes to be destroyed. City drain pipes failed during the heavy rains that winter. The city continues to own seven of the homes that were bought to settle a lawsuit. The city manager and several police officers lived in the homes for many years, but due to recent slide activity, the city has decided to demolish the homes.

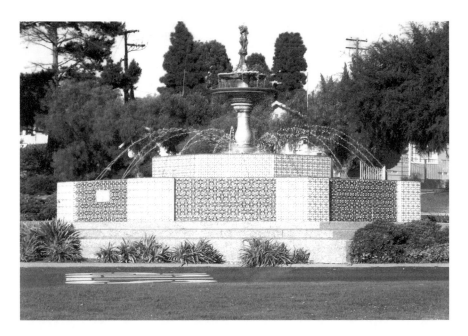

The Lunada Bay fountain before the 2008 refurbishment. *Photo by Bruce Megowan.*

Beautiful Lunada Bay, with Catalina Island in background. *Photo by Bruce Megowan.*

Palos Verdes Estates Landmarks

NEIGHBORHOOD CHURCH—One of the more spectacular buildings in Palos Verdes Estates is the mansion constructed in 1928 for J.J. Haggarty of Haggarty's Department Stores. In addition to the magnificent villa, Haggarty also built a pier extending from his property into the ocean for the purpose of launching his boats. False rumors claimed that he used it for smuggling imports into the country. This pier, just to the south of the Swim Club, can be seen in old photographs of the Swim Club. The mansion was never occupied by the Haggartys, as Mrs. Haggarty preferred to stay at the family estate on Adams Boulevard closer to the city of Los Angeles. Mr. Haggarty died in 1935, and the mansion was vacant for many years; soon it was rumored to be haunted. Sometime in the early 1940s, an eccentric inventor purchased the property and furnished it with a large collection of nude statues and paintings. Finally, the Neighborhood Church acquired the property in 1950 for only $70,000.

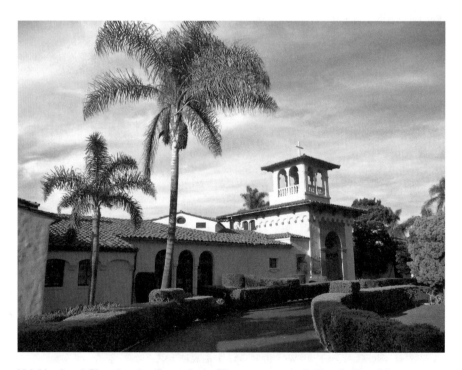

Neighborhood Church today (formerly the Haggarty mansion). *Photo by Bruce Megowan.*

PALOS VERDES ESTATES GATEHOUSE—This stone, castle-like structure at 4420 Via Valmonte, near the entrance to Palos Verdes Estates on Via Valmonte and just up from Hawthorne Boulevard, was built in 1926 as a guard's house for what was intended to be a gated entrance to the new Palos Verdes Project. The structure is a two-story, fifteen-foot-diameter round building with eighteen-inch-thick walls. It has two floors; a bedroom and bathroom area is upstairs, and a living room with a stone fireplace and a kitchen are downstairs. This structure was known as the "Stone Tower," "Tower House" and the "Mirlo Gate Lodge" (Via Valmonte, originally named Via Mirlo, was renamed Hawthorne Avenue prior to Hawthorne Boulevard being extended south over the Peninsula Hill to the ocean and then renamed Via Valmonte). Title to this structure was taken by Palos Verdes Estates in 1939 when the city was incorporated, and it is leased by the city as a residence.

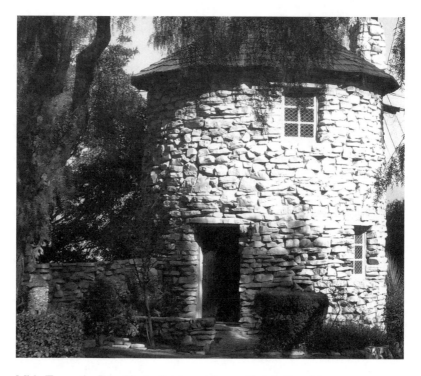

Mirlo Tower, the Palos Verdes Estates gatehouse. *Photo by Bruce Megowan.*

MALAGA COVE LIBRARY—The Malaga Cove Library opened on June 3, 1930, as the Palos Verdes Library and Art Gallery. In keeping with the vision for the new community that was being established on the Peninsula, the library benefited from some of the best design thinking of its time. The building architect, Myron Hunt, was already known for his work on the Rose Bowl, the Pasadena Public Library and other area buildings. The Olmsted brothers were once again the landscape architects.

In many ways, the design of the library—with its inclusion of a multipurpose gallery room designed for both art exhibits and public performances and its beautiful outdoor spaces—was ahead of its time and foreshadowed the role that libraries play today as community gathering places and not just repositories for books.

Palos Verdes Beach and Athletic Club

The Palos Verdes Bathhouse and Beach Club opened in June 1930, at a cost of $15,000, as a community amenity to be enjoyed by new property owners in the Palos Verdes Project, which at the time consisted of 499 residents. Noted architect Kirtland Cutter designed this beautiful landmark on the beach in Malaga Cove. In 1939, the newly incorporated city of Palos Verdes Estates assumed ownership from the Palos Verdes Homes Association. For many years, the pool was a saltwater plunge. At some point in time, a large cinder block wall was constructed next to the pool, apparently to protect from storm damage, but it completely cut off any view of the adjacent ocean.

On September 3, 1946, the structure experienced a fire that destroyed the upper levels of the facility. The damage was left unrepaired; however, city residents continued to use the pool facilities. In 1965, the club was renamed in memory of the city's first mayor, H.F.B. Roessler, who at the time of his death was serving his twenty-sixth year in office. From its inception, the club was only open during the summer, and Larry Bark ran the summer swim program for thirty years, beginning in 1957.

In 1988, the building finally became a serious safety hazard, and the City of Palos Verdes Estates was faced with a critical decision—demolition or renovation of the historic facility. Fortunately, a plan was formulated by concerned citizens of the city to save the facility. This group was composed of several very dedicated people, including Jerry Glass, John Bates, Ruth Gralow, Jack Duston, Deanne Myers, Bill Finer, Dave Bryant, Judy Burke, Dorothy and John Flood, Mark Paulin, Karen Gottdamer

Palos Verdes Beach and Athletic Club (Roessler Memorial Pool). *Photo by Bruce Megowan.*

and Jo Scudamore. Under the auspices of the city, the Palos Verdes Beach and Athletic Club Foundation, a nonprofit organization, was formed and raised $2 million by selling memberships in the club. The land under the club is owned by the city, and the Swim Club operates under a concession agreement with the city.

John Bates supervised the renovation, and architect-designer Juan Forteza redesigned the club and did an incredible job of creating some of the most remarkable public spaces of any club in the country. The renovated club, after a three-and-a-half-year construction period—with the old wall removed that had disrupted the view of the ocean and with a brand-new state-of-the-art infinity pool added—was dedicated in July 1993 as the Palos Verdes Beach and Athletic Club. The new club also included a steam room, a dry sauna, an aerobic and yoga room, kayak storage, a Jacuzzi and a weight and workout facility. The club, now open year-round, continues as a focal point of social and recreational activities for its 610 members, as well as for residents and the public through the payment of a daily use fee.

Palos Verdes Country Club

Shortly after Frank Vanderlip acquired the sixteen-thousand-acre Palos Verdes Peninsula with a group of investors in 1913, he developed plans for a golf course on his property. Original plans included the construction of a magnificent golf club on the bluffs overlooking Portuguese Bend, to be known as Los Palos Verdes Country Club. The grounds were to include a clubhouse with 150 guest rooms, locker rooms and numerous dining and community rooms. Other amenities were to include a large swimming pool, tennis courts, polo grounds and a yacht club with a concrete pier. World War I, however, curtailed these plans for the country club.

In the early 1920s, developers of the Palos Verdes Project built a number of amenities to promote lot sales in the new community of Palos Verdes Estates. The golf club was constructed at the same time as other amenities of the new city, such as the La Venta Inn and the Palos Verdes Swim Club. Palos Verdes Golf Club opened on November 15, 1924. The golf course was designed and built by the team of William P. "Billy" Bell and George C. Thomas. It is a classic example of those courses built during the era that has become known as the "Golden Age of Golf Course Architecture." Other examples of their work in Southern California include the North Course at Los Angeles CC, Riviera CC and Bel Air CC, as well as the Ojai Valley Inn Golf Course. The course was designed with ocean views from fourteen of its eighteen holes. The club was very popular in the 1920s, with celebrities such as Douglas Fairbanks often seen there.

The land on which the course is situated is owned by the City of Palos Verdes Estates, and the club is operated under a concession agreement with the city. The club is semi-private, with private memberships sold giving club

Palos Verdes Country Club. *Photo by Bruce Megowan.*

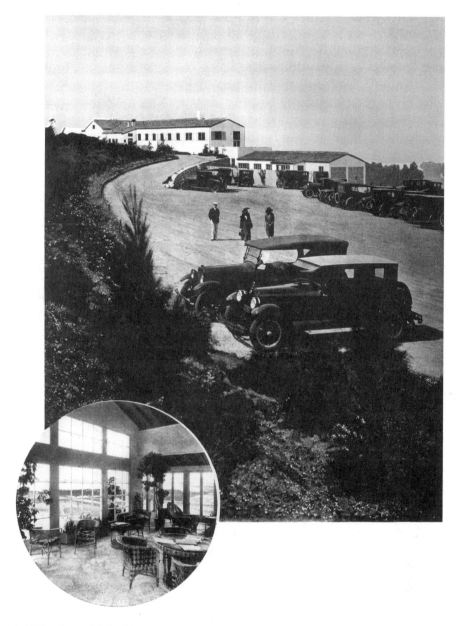

A 1920s photo of Palos Verdes Country Club. *Courtesy Don Christy Collection.*

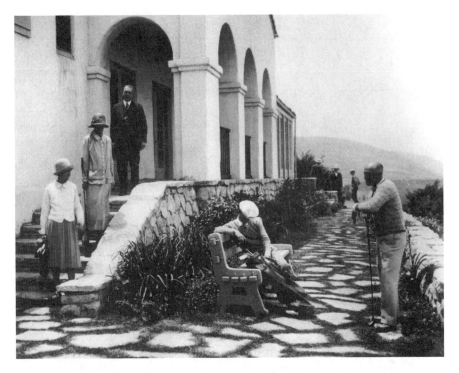

A 1926 photo of Palos Verdes Country Club. *Courtesy Don Christy Collection.*

members priority tee times; only club members and residents of the city (in the afternoon) may play on the weekends. The public does have access at certain times and days in the middle of the week, though.

The clubhouse was designed by Clarence E. Howard, with landscaping design by the Olmsted Brothers firm. The landscaping included hundreds of eucalyptus trees, which line the fairways of several holes, most of which had been planted years before by early ranchers. The clubhouse cost $60,000 to build, and it was determined almost immediately that it needed to be expanded. Both the course itself and its restaurant quickly became overcrowded. The building was extended sixty feet to the east to make room for a new golf shop and caddy house. The clubhouse was completely remodeled in 2007.

The country club hosts twice-monthly meetings of the Palos Verdes Breakfast Club, a group of Palos Verdes Estates men who have met since the club's founding in May 1942. The intent of the club was to bring the people of the community closer together during the trying times of World War II.

The La Venta Inn

The La Venta Inn was constructed in 1923 in what is now the city of Palos Verdes Estates at a cost of $17,000 and was originally named Clubhouse 764; it was referred to in some early historical documents as the Wayside Inn. The La Venta Inn was the first structure constructed on the Peninsula. Architects Walter and Pierpont Davis designed the building, and the famous Olmsted brothers designed the gardens.

Given the name "La Venta," meaning "the sale," it was originally built by the managers of the Palos Verdes Project as a clubhouse for the entertainment of prospective land developers and home buyers, but it became the social center for Palos Verdes, hosting many weddings and dinner outings.

The first large La Venta party was held in 1924 on the three-acre site, when two hundred realtors were wined and dined in the beautiful setting. The Palos Verdes Project's plan was a huge success, and soon homes started

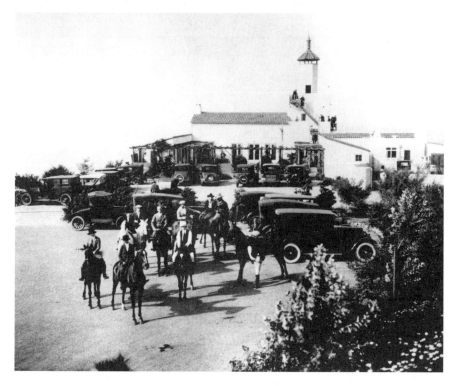

A 1926 view of La Venta Inn. *Courtesy Don Christy Collection.*

La Venta Inn today. *Photo by Bruce Megowan.*

appearing on the landscape following the Mediterranean architectural example of the inn. The inn was also used as a backdrop for several silent movies in the late 1920s.

In the 1930s, the La Venta Inn became a famous black-tie restaurant, and many Hollywood celebrities of the time used the inn as a weekend retreat, including Charlie Chaplin, Rosalind Russell, Greta Garbo, Cary Grant, Charles Lindbergh, Errol Flynn, Betty Grable, Bob Hope, Gloria Swanson and Tyrone Power.

Frank Conroy, a Broadway stage actor, purchased the inn in 1941 and hosted lavish Hollywood parties, but with the onset of World War II, bomb scares and blackouts prevented visitors from attempting the long, winding drive to the inn. The inn was all but abandoned. During World War II, La Venta's tower was utilized as a twenty-four-hour lookout point for the U.S. Coast Guard.

In 1944, at the end of World War II, the inn was purchased by the Schnetzler family, and they converted it into their own private residence. They worked on renovations and lovingly brought the expansive gardens

back to life. Dorie Matthews, daughter of the Schnetzlers, told the *Daily Breeze* that there were occasions when people "would just come in the front door, sit down and ask for a menu," not realizing that it was now a private residence. The Schnetzlers eventually reopened the inn to the public in 1957, and for ten years, Mrs. Schnetzler assisted with arranging weddings and celebrations on the grounds, acting as innkeeper.

Over the years, there have been instances in which developers made overtures to buy this valuable property, but the community consistently rallied to the defense of the inn and its history. It was eventually designated a nationally recognized historical landmark. Since 1992, the New York Food Company has managed the property and hosts numerous private party functions every year.

Fred Roessler

One name stands alongside that of Frank Vanderlip in the history of Palos Verdes Estates: Fred Roessler. Frank Vanderlip is known as the "Father of Palos Verdes," but Fred Roessler is the "Father of the City of Palos Verdes Estates."

Hans Frederick Bernard Roessler, or Fred, as he preferred to be known, served as the mayor of Palos Verdes Estates for twenty-five years, from 1940 until his death in 1965. He was the city's first mayor, taking office after leading the fight to incorporate that saw success in 1939. He was elected to the first city council, and its members voted him to be the city's first mayor.

After serving in the U.S. Army in France during World War I, Roessler settled in Los Angeles, where he married Edna Lucille Hansen in 1921. He and Edna first moved to the Peninsula in 1931 to a house in the Miraleste area. Together, they helped Margaret Chadwick establish Chadwick School, contributing $100,000 toward the project. The prestigious school opened in January 1938. Before then, Chadwick had been educating children, including those of the Roesslers, in her home.

The Roesslers moved to a house on Via Coronel in December 1937 in what would become Palos Verdes Estates. Roessler later recalled getting a phone call the very night they moved in asking him to help with the drive to incorporate PVE as a city. After a bitter two-year struggle, the measure calling for incorporation passed on December 9, 1939; 419 votes were cast, and the final tally was 213 for, 206 against. Palos Verdes Estates officially became a city of the sixth class on December 20, 1939.

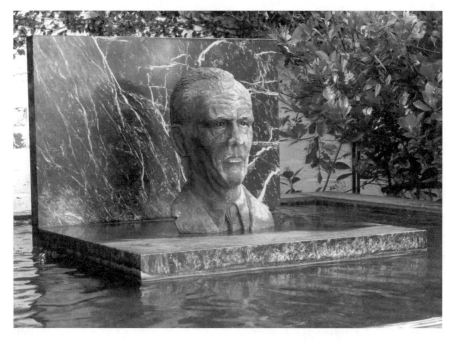

Bust of Fred Roessler in fountain in front of Palos Verdes Estates City Hall. *Photo by Bruce Megowan.*

During his tenure as mayor, the fiscally conservative Roessler kept the city on a tight leash, never once allowing it to go into debt with the issuance of municipal bonds. He also fought to preserve the city's rural residential character, resisting the urge to build larger roads and add other elements found in the South Bay's more commercially developed areas.

As a member and onetime president of the Palos Verdes Homes Association, he worked to limit business development and to keep the city's Spanish character, including requiring houses to have tile roofs. Roessler had suffered from heart trouble for years and had been hospitalized three times before suffering a fatal heart attack early in the morning of January 30, 1965. He was seventy-one.

The city never forgot its first mayor. A memorial fountain was dedicated to him in 1968 at Palos Verdes Estates City Hall on Easter Sunday; a bust of him also stands there today. The city renamed the Palos Verdes Swim Club pool, opened in 1930, to Roessler Memorial Pool in April 1969.

Palos Verdes's Early Road Development

Road construction on the Palos Verdes Peninsula did not take place until the 1920s. Palos Verdes Drive West in the Valmonte and Malaga Cove area was the first road developed as part of the original Palos Verdes Project. Palos Verdes Drive East in the Miraleste area, then known as Western Avenue and which was then part of the Palos Verdes Project, was then developed to facilitate lot sales there.

In 1926, the coast road connecting Redondo Beach to San Pedro, previously called Granvia La Costa and now called Palos Verdes Drive West, was completed, including the monumental "Douglas Cut," which was blasted away above Bluff Cove. This road was simply referred to as the "Coast Road." Old maps show the Coast Road connecting to "Western Avenue," which later was renamed Palos Verdes Drive East and now runs into Narbonne Avenue on the north.

Western Avenue later was constructed between Narbonne/Palos Verdes Drive East and Gaffey Street in San Pedro. Pacific Coast Highway was named Redondo and Wilmington Road at that time and connected to Anaheim Street at the current junction with Western Avenue. Palos Verdes Drive North was completed in the mid-1930s.

The extension of Crenshaw from Crest Road to Palos Verdes Drive South was never completed due to the Portuguese Bend landslide in the mid-1950s, which was triggered by road grading for the extension of Crenshaw Boulevard.

Road construction moved forward rapidly in the late 1950s and through the mid-1960s. Construction of Crenshaw Boulevard up a canyon from Palos Verdes Drive North to Crest Road commenced in the middle of June 1950 and was completed in September 1951, utilizing labor for the construction via inmates at County Detention Camp No. 7 in the Peninsula Center area. Crest Road, constructed by the developers of the Palos Verdes Project, ran from Palos Verdes Drive East across the top of the hill and then down to Palos Verdes Drive West along the current lower portion of Hawthorne Boulevard. Before extending Crenshaw up the hill, Crenshaw had extended to the gated

Following pages: Late 1930s sales brochure map of Palos Verdes Roads. Note that Western Avenue was not yet constructed. Pacific Coast Highway was known then as "State Street (Highway 101)." Palos Verdes Drive North was completed in the early to mid-1930s. *Courtesy Don Christy Collection.*

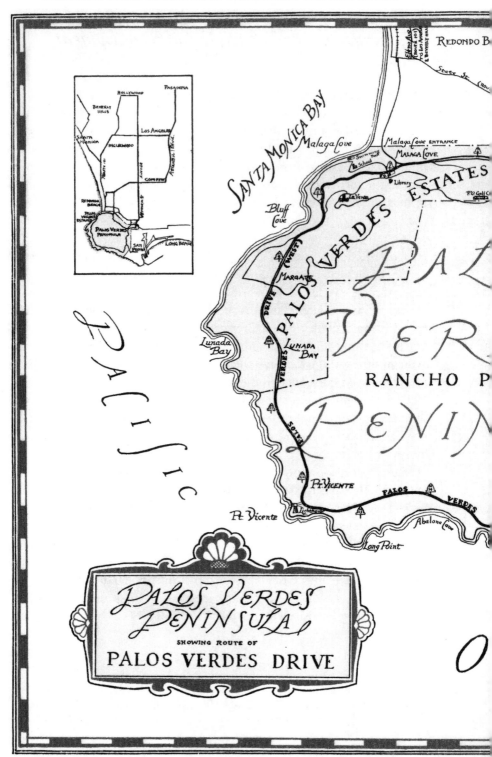

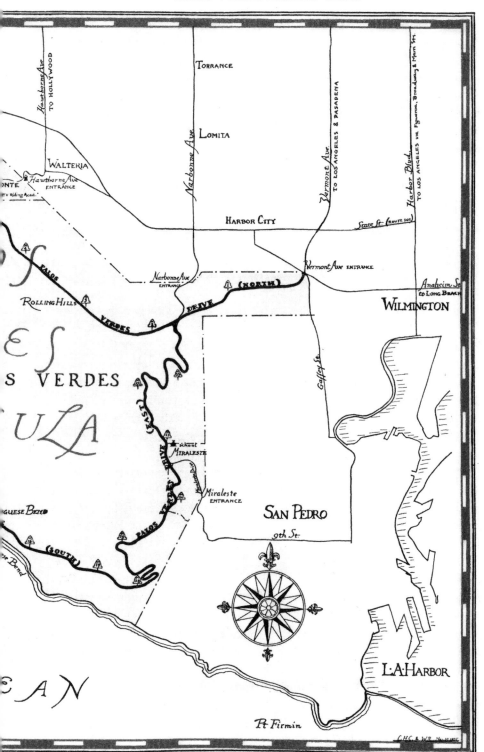

entrance to Rolling Hills, and that portion of Crenshaw was then renamed Rolling Hills Road.

Construction of Hawthorne Boulevard through the Peninsula was completed in several segments. Hawthorne Boulevard was completed from Silver Spur Road to Crest in 1959. The segment from Palos Verdes Drive North to Silver Spur Road was completed in 1961. Hawthorne Avenue veered right into Palos Verdes Estates at what is today called Via Valmonte. After several years of planning, the final segment extending Hawthorne Boulevard from Newton in Torrance to Palos Verdes Drive North was completed in 1965.

Palos Verdes Secrets

What are the large round white domes above Palos Verdes Drive East, just up from Palos Verdes Drive South? The two large round white buildings visible from Palos Verdes Drive East at the top of the hill house a radar facility that is still operational. It is run by the Federal Aviation Administration, which continues to use the facility for long-range radar. The Los Angeles Air Route Traffic Control Center uses the facility to control air traffic into and out of Los Angeles. The FAA took over the facility from the U.S. Air Force in 1960.

Why does the Palos Verdes Art Jury have jurisdiction over a part of Rancho Palos Verdes in the Miraleste area? The Miraleste area of Rancho Palos Verdes was part of the original Palos Verdes Project which was developed in the 1920s and 1930s and was subject to the same deed restrictions that were recorded on the lots that later became part of the city of Palos Verdes Estates, which included architectural review authority by the art jury of the Palos Verdes Homes Association.

How did the beach, which is the last beach before the start of the Palos Verdes Peninsula in Torrance, get its name "Rat Beach"? There are four stories about this. One says the name comes from an acronym for the beach "Right After Torrance." Another says that it stands for "Redondo and Torrance" beach. The two most recent ones that I have heard are that the name was coined by local surfers. The first story says that "Rat Sh-t Beach" was coined by local surfers in the early '60s because there was little sand at that end of the beach at that time. They didn't dredge and add sand until 1968–69. There was also a seasonal creek that attracted a lot of rats, which of course left a lot of rat poop, hence the name. The second story told by members of the Haggartys

Surfing Club was that it was named in honor of professional surfer Rick Irons after his pet rat.

Why are there such large median strips on Palos Verdes Drive in Lunada Bay and Via Valmonte? The original planners of the Palos Verdes Project planned Palos Verdes Drive in these areas to accommodate the Pacific Electric Trolley cars, which were an integral part of the public transportation network in Los Angeles County in the late 1920s.

Rancho Palos Verdes City Hall was a Nike missile base. From 1955 to 1974, a Nike missile battery was located at the site of the current Rancho Palos

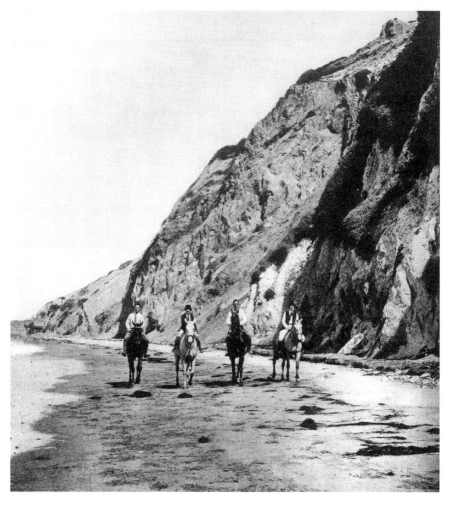

Horses on the beach below Malaga Cove in 1926, from an early marketing brochure. *Courtesy Don Christy Collection.*

Large median strip at entrance to Palos Verdes Estates in Valmonte. *Photo by Bruce Megowan.*

Verdes City Hall. The city hall for Rancho Palos Verdes was relocated to the administration buildings of the former Nike missile site in 1975, shortly after the city of Rancho Palos Verdes was incorporated in 1973.

Is the Vanderlip estate haunted? No, it is definitely not haunted, despite the persistent rumors. The home was built by Frank A. Vanderlip Sr., the original developer of the Palos Verdes Peninsula, who purchased the entire Palos Verdes Peninsula in 1913 with an investment group. Two completely untrue stories have circulated on the Internet that the wife of Frank Vanderlip went crazy there or that a daughter of Frank Vanderlip had an illicit affair and was put into an insane asylum across the street. These stories are ridiculous, but the stories still appear on several websites devoted to haunted places.

Is there a nudist beach in Rancho Palos Verdes? Although it is illegal, many sun worshipers, without clothing, have been known to frequent a beach at Smuggler's Cove, in the Portuguese Bend area of Rancho Palos Verdes. This beach is accessed by a trail across the street from Pepper Tree Drive on Palos Verdes Drive South.

Why do some of the areas of the Palos Verdes Peninsula have a mailing address of "Palos Verdes Peninsula," instead of one of the four cities on the Peninsula? There is

a small area at the northern part of the Palos Verdes Peninsula within the boundaries of the city of Rolling Hills Estates that is in an unincorporated area and is governed only by the County of Los Angeles. This area is the residential area on either side of Crenshaw Boulevard, south of Palos Verdes Drive North, which is accessible only from Palos Verde Drive North, as well as a small area just south of the intersection of Rolling Hills Road and Crenshaw Boulevard.

The original plans for the Palos Verdes Project had several different names planned for Palos Verdes Drive. Palos Verdes Drive North was originally planned to be named Granvia Valmonte from Malaga Cove Plaza through to Anaheim Street. Palos Verdes Drive West was to have been named Granvia La Costa.

Palos Verdes Estates once tried to annex Marineland. In early 1965, the City of Palos Verdes Estates attempted to annex a portion of present-day Rancho Palos Verdes totaling 2.92 square miles bordered by High Ridge Road to the east and the Pacific Ocean, including the Marineland Park, in an attempt to broaden its tax base. This effort failed, however.

Who owns Portuguese Point? Portuguese Point, in the Portuguese Bend area of Rancho Palos Verdes, is a peninsula adjacent to Abalone Cove, which was once part of the Harden estate; it is now owned by the City of Rancho Palos Verdes and is part of Abalone Cove Shoreline Park.

Palos Verdes Colleges

The Palos Verdes Peninsula has had an interesting history in relation to colleges and universities. In the 1920s, UCLA had studied Palos Verdes as a potential location for the relocation of its campus from north Vermont Avenue in Los Angeles. Palos Verdes developers had offered to donate one thousand acres in the Peninsula Center area. In the early 1960s, a new state college was planned at the top of the Peninsula and briefly held classes as Palos Verdes State College in the Peninsula Center, until Cal State Dominquez Hills was constructed.

In 1947, a small, private, independent junior college was founded on the Peninsula. Enrollment reached a peak of only about one hundred students. The first graduating class in 1949 was fourteen students. Palos Verdes College occupied the present-day location of Rancho del Mar High school, next to the entrance to Rolling Hills near the intersection of Crenshaw and Crest Roads. This site was an air force barracks installation

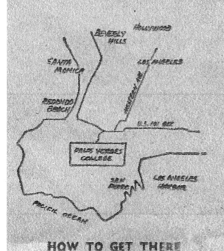
A 1947 ad for enrollment at Palos Verdes College. *Photo by Bruce Megowan.*

during World War II. Elaborate plans for a permanent location at the top of a hill overlooking the valley location of the temporary campus were drawn up but never realized. Elin and Kelvin Vanderlip were early patrons of the campus; however, fundraising for the campus struggled over the years. One such effort started was the Palos Verdes Homes Tour, which continues today as a fundraising event for the Palos Verdes Art Center. The campus became a four-year college in 1954, but the campus finally closed down in 1955.

Marymount California University (MCU) is an independent, coed residential college located in the Miraleste area of Rancho Palos Verdes. Marymount was the first Catholic junior college in California and began as a liberal arts college for women in Los Angeles in 1948. In the mid-1960s, discussions began on admitting women to the undergraduate program at Loyola University. The affiliation of Marymount College and Loyola University began in 1968 when Marymount's four-year program relocated to the Loyola University campus in Westchester, Los Angeles. In 1968, Marymount opened its two-year program on the Palos Verdes campus. The merger of Marymount College and Loyola University was completed in 1973, forming Loyola Marymount University.

The Marymount Palos Verdes California College remained incorporated as a separate two-year program, having received accreditation in 1971. In 1986, the name changed again to Marymount College Palos Verdes.

The college began to offer four-year Bachelor of Arts degrees in 2012, as well as master's degrees in certain studies, which prompted its name change to Marymount California University. Currently, first- and second-year students take core courses at the Palos Verdes campus. Upper-division and graduate courses take place at the urban Waterfront Campus in San Pedro.

UCLA and CSUDH Almost Came to Palos Verdes

A section of one thousand acres was originally set aside by the planners of the Palos Verdes Project for a university campus. In 1921, a proposal was made for the relocation of the southern branch of the University of California (which was later renamed UCLA), which was then located on Vermont Avenue in Los Angeles (built in 1914 and home to Los Angeles City College since 1929).

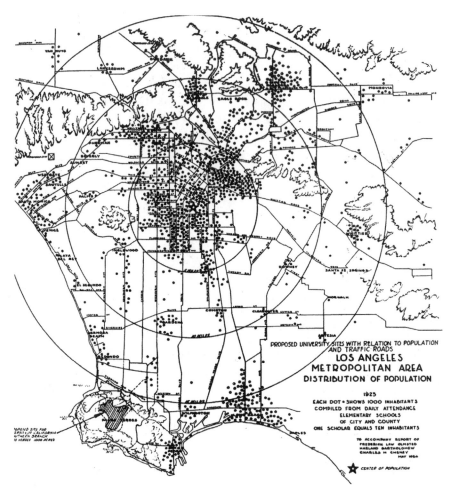

A 1925 map showing four proposed locations for the Southern Branch of the University of California, including the Palos Verdes Peninsula, Westwood, Burbank and Fullerton. *From the* Palos Verdes Bulletin *(January 1925).*

The proposed site was in the center of the Palos Verdes Peninsula, where Peninsula High School, the Peninsula Shopping Center and the Avenue of the Peninsula Shopping Center are located. The proposal, in addition to the donated one thousand acres, included other inducements: $1 million, the construction of a model grammar school and a model high school to be run by the University's Department of Education, a marine biological station and public aquarium, an art museum, a theater seating 1,500, a boathouse at Portuguese Bend and a football stadium to

seat 90,000. After considering seventeen other sites, UCLA held classes on its new Westwood campus in 1929.

In 1963, Great Lakes Property Inc. planned to sell 107 acres of land near the intersection of Hawthorne Boulevard and Crest Road at the top of the Palos Verdes Peninsula as a site for what was originally named South Bay State College and then renamed California State College at Palos Verdes (CSCPV). The State of California allocated funds to acquire this land and actually began classes for twenty-seven freshmen and fourteen juniors in a bank building in the Peninsula Center area in September 1965.

After extensive planning and beginning eminent domain acquisition of the site, due to rising land values this site was abandoned for consideration in mid-1965. Three other sites on the Palos Verdes Peninsula were then considered, including one on the northern slopes of the Peninsula, incorporating the Chandler gravel pit and the county sanitary landfill on unincorporated land between Crenshaw and Hawthorne Boulevards, as well as on land overlooking Palos Verdes Drive South in Rancho Palos Verdes adjacent to San Pedro. Other potential sites included Fort MacArthur in San Pedro and Dominquez Hills.

After the Watts riots in South Central Los Angeles in August 1965, however, one of the issues raised by civil rights leaders was the lack of access to colleges in the area. In response, the California legislature decided not to approve the Palos Verdes sites, and the campus was located in Carson as the California State University–Dominquez Hills.

Portuguese Bend

The Vanderlip Estate

Immediately after purchasing the Palos Verdes Peninsula in 1916, Frank A. Vanderlip Sr. engaged a study to compile weather information about the entire Peninsula. From the data of that study, Mr. Vanderlip determined that the most consistently mild, sunny and fog-free weather was in the Portuguese Bend area of the Palos Verdes Peninsula. Mr. Vanderlip chose that area as the site for the Vanderlip summer home, which was constructed in 1916; it was the first residence on the Palos Verdes Peninsula other than a few ranch houses that no longer exist. The home was initially called the Old Ranch Cottage, though it is now known as just the Cottage.

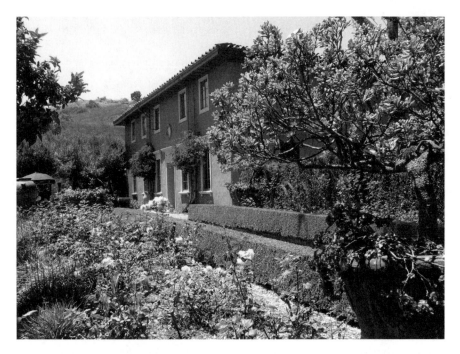

Villa Narcissa. *Photo by Bruce Megowan.*

A guesthouse known as the Villetta was built in 1924 and renamed Villa Narcissa for Frank A. Vanderlip Sr.'s wife, Narcissa. The Villa has almost twelve acres of land, including wonderful gardens and a cypress allee with many steps leading up to a Doric colonnade, built to draw the eye up the allee, and from which one can enjoy the view at the top. Frank and Narcissa preferred to stay in the Cottage when visiting and used Villa Narcissa to house guests. Mr. Vanderlip also constructed a barn and stables called the Farmstead that later became the Portuguese Bend Riding Club.

At the top of Narcissa Drive, just past the Farmstead/Portuguese Bend Riding Club, was the proposed site for the Villa Palos Verdes—a grand villa modeled after the Villa Papa Guilio in Italy (today the Etruscan Museum in Rome)—which Mr. Vanderlip planned to build. The Great Depression put a stop to those plans, however, and when Frank Vanderlip died in June 1937, his grandiose plans died with him.

Narcissa gave Villa Narcissa to her son, Kelvin Vanderlip, and his bride, Elin, as a wedding gift in 1946. Kelvin and Elin lived in the Cottage for the first five years of their marriage, as the Villa initially was not set up for daily living. It was not until 1951 that the open-air staircase to the upstairs

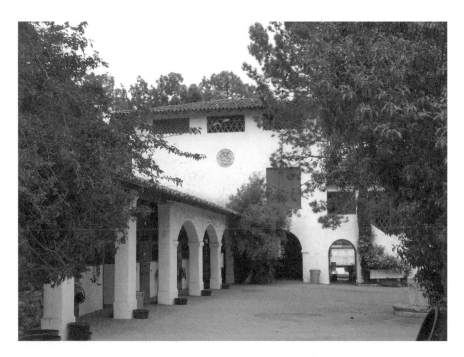

The Farmstead, now the Portuguese Bend Riding Club. *Photo by Bruce Megowan.*

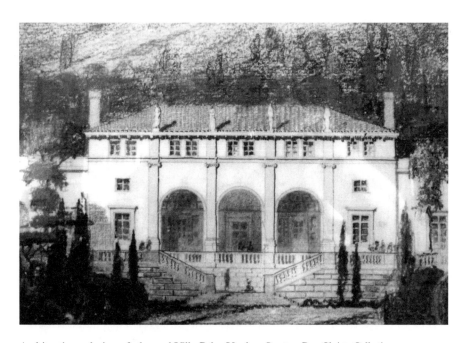

Architect's rendering of planned Villa Palos Verdes. *Courtesy Don Christy Collection.*

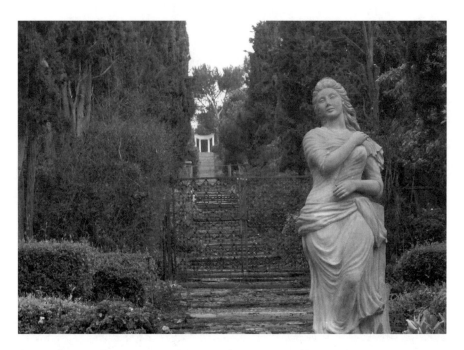

Cypress-lined garden steps to the "Temple" area at the top of Vanderlip estate. *Photo by Bruce Megowan.*

bedrooms was enclosed to create an entrance foyer, and a kitchen was added as well as additional bedrooms upstairs. Elin continued to add on to the Villa Narcissa, including ten small rental cottages for income to maintain the property, and care for her extensive gardens until her death in 2009. The Villa is still owned by the Vanderlip family.

The Cottage

The Cottage in Portuguese Bend was constructed in 1916 as the first residence on the Palos Verdes Peninsula other than a few ranch houses. According to Frank A. Vanderlip Jr. (Frank A. Vanderlip Sr.'s oldest son), the home was copied from their vacation house in Shrub Oak, New York. The Cottage is located at 99 Vanderlip Drive, and although it is now more than 3,800 square feet, with four bedrooms and four baths, it was initially called the Old Ranch Cottage.

The initial portion of the home was partially pre-constructed before being assembled at the home's site and included a small maid's bedroom, a living

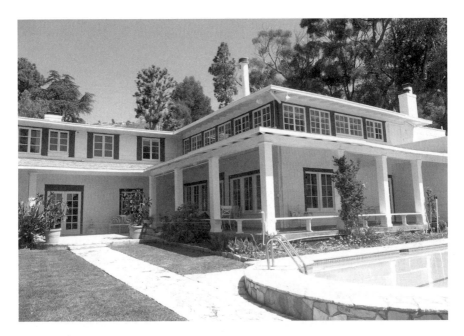

The Cottage in 2008. New owners are in the process of renovation. *Photo by Bruce Megowan.*

room and a small kitchen on the main floor; a stairwell to two bedrooms and two large bathrooms (the two bedrooms were later combined into one large bedroom); and a covered porch. A larger kitchen and family room were added later. The builder made a mistake in locating the house on the lot and did not orient the home facing the ocean. Narcissa Vanderlip, Frank A. Vanderlip Sr.'s wife, was very disappointed, so Frank had constructed an additional wing to the house that included a new living room, two bedrooms and a bath upstairs facing the ocean view.

Narcissa Vanderlip loved Asian design, and the interior of the living room had intricate Chinese carvings on the valances over the doors, windows and closets, as well as some custom-made furniture.

For the most part during the 1920s, Frank A. Vanderlip Sr. lived in New York at Beechwood, his Scarborough-on-Hudson estate. Frank A. Vanderlip Sr.'s wife, Narcissa Cox Vanderlip, was a leading suffragist in New York and one of the founders of the New York League of Women Voters. She was also a good friend of Eleanor Roosevelt and was instrumental in Eleanor's involvement in politics. Narcissa and Frank had six children (Narcissa, Charlotte, Frank Jr., Virginia, Kelvin and John).

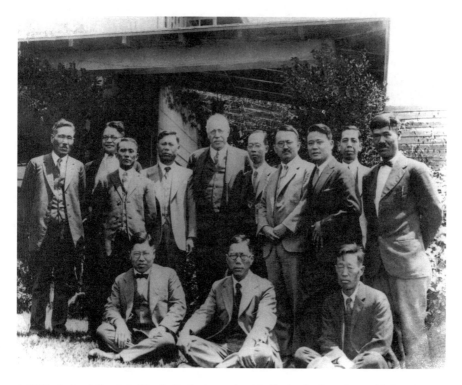

A 1928 photo of Frank A. Vanderlip Sr. (center), with dignitaries from Japan. Nobusuke Kishi, who was to become Japan's prime minister in the 1950s, stands second from the left in the back. *Courtesy Palos Verdes Library District Local History Collection.*

Next door to the Cottage, Mr. Vanderlip constructed a separate three-car garage with servants' quarters on the upper level, later enlarged by subsequent owners.

In the mid-1950s, a large landslide hit the Portuguese Bend area when grading was done to extend Crenshaw Boulevard from the top of the Peninsula to Palos Verdes Drive South. The Vanderlip family relocated a small building that had served as the original real estate sales office for the Portuguese Bend area to a lot adjacent to the Cottage, where it served as a one-bedroom guesthouse.

Mr. Vanderlip and his family always stayed at the Cottage when visiting Palos Verdes until his death in 1937. Narcissa continued to visit the Cottage periodically thereafter. Son Kelvin Vanderlip and his wife, Elin, occupied the Cottage from 1946 to 1951, when they moved into the Villa Narcissa next door. Frank A. Vanderlip Jr., who lived in New York, owned the Cottage after his mother's death in 1966. Later, John Vanderlip, Frank

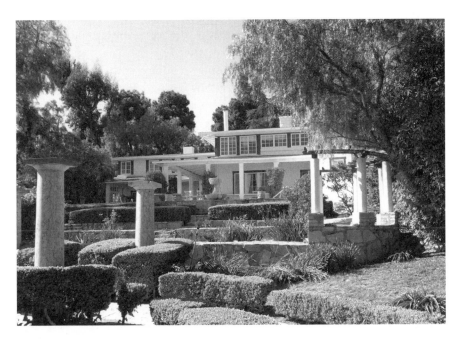

Gardens of the Cottage in 2008. New owners have removed these gardens. The columns were brought to the site in the late 1920s and were planned to be used in the construction of Frank Vanderlip's planned Villa Palos Verdes, a grand villa to have been modeled after the Villa Papa Guilio in Italy. *Photo by Bruce Megowan.*

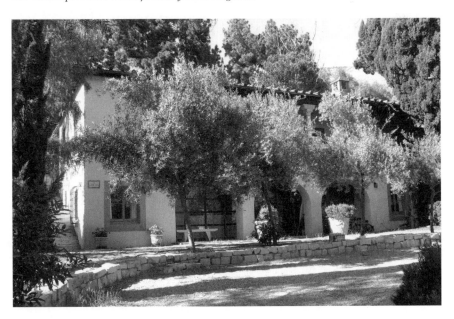

La Casetta. *Photo by Bruce Megowan.*

Sr.'s youngest son, lived in the Cottage with his second wife, Suzanne, beginning in 1977.

Frank A. Vanderlip Sr. loved birds, and for many years, he maintained an aviary just below the Cottage, including a pond for the birds. A bird hospital and concrete streambed were also built. Mr. Vanderlip introduced the peacocks to the Palos Verdes Peninsula.

The Cottage was still owned by Suzanne Vanderlip, the widow of John Vanderlip, until her death at the age of eighty-seven on November 17, 2010, and was sold for the first time outside of the Vanderlip family in September 2012. Maureen Megowan was the listing agent on the sale.

Elin Vanderlip: The Grande Dame of the Palos Verdes Peninsula

Elin Regina Brekke was born in 1919 in Oslo, Norway, the daughter of a civil engineer. In 1946, Elin met Kelvin Vanderlip, one of the sons of Frank Vanderlip Sr., on a weekend cruise to Catalina and married him soon thereafter. The couple had four children: Kelvin Cox Vanderlip Jr., Henrik Nils Vanderlip Sr., Katrina Vanderlip and Narcissa Vanderlip-Fuller.

During the 1940s, Elin and Kelvin hosted many Hollywood celebrities at Villa Narcissa, including Jimmy Stewart, Merle Oberon, Charles Laughton, and Peter Ustinov. Myrna Loy lived there before World War II, and Paulette Goddard and Burgess Meredith honeymooned there. Kelvin often hosted his good friend Ted Geisel (aka "Dr. Seuss"), who later became the godfather to Kelvin Cox Vanderlip Jr. Over the course of the sixty years she lived at Villa Narcissa, Elin entertained artists, writers and royalty (including Queen Noor of Jordan and King Haakon of Norway), as well as figures like Rose Kennedy.

Elin and Kelvin were instrumental in the establishment of many landmarks on the Palos Verdes Peninsula. Kelvin headed up the school board of Chadwick School—the land for it had been donated by his father Frank A. Vanderlip Sr., who had a lifelong devotion to education. The Vanderlip family donated land and oversaw plans for the Wayfarers Chapel and built a four-room schoolhouse (now St. Peters by the Sea Church). As president of the Los Angeles Chamber of Commerce, Kelvin lobbied hard for Marineland. Elin and the Vanderlip family also played a large role in the development of the Portuguese Bend Riding Club (which had been originally built by Frank A. Vanderlip Sr. as riding

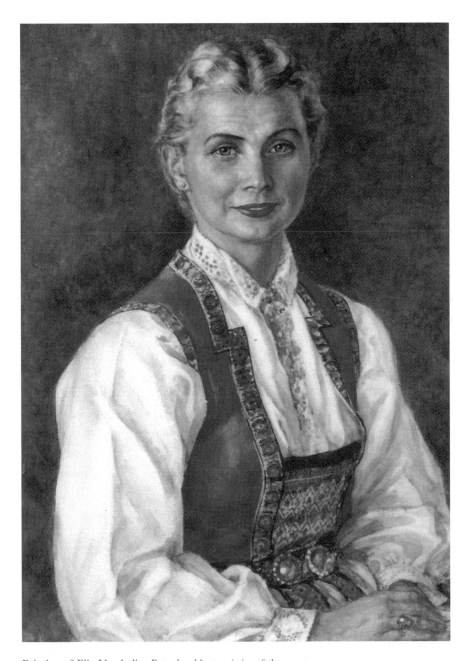

Painting of Elin Vanderlip. *Reproduced by permission of the owner.*

stables known as the Farmstead), the Portuguese Bend Beach Club and Marymount College.

Kelvin sold the land for Nansen field to the Norwegian government at a highly discounted price. The field was originally a soccer field for Norwegian seamen visiting the local port of San Pedro and is now owned by a California nonprofit called Seamen of Norway Inc. The field, named for Fritijof Nansen, Norway's great Arctic explorer and diplomat, is now used by youth and adult soccer clubs and by Southern California's Scandinavian Community for cultural, athletic and social events.

For many years, Elin was a patron of the arts, particularly supporting French art, raising $6 million for art restoration through her foundation, Friends of French Art. Elin spoke seven languages, and although she never went to college, she was awarded two of France's highest cultural honors, the Chevalier de la Legion d'Honneur and Commander of the Order of Arts and Letters.

Although Elin never remarried after husband Kelvin succumbed to lung cancer at the age of forty-six in 1956, she found love for forty years with motion picture producer Lehman "Lee" Katz (*The Train, Apocalypse Now, Fiddler on the Roof*), with whom she traveled to locations all over the world. Katz died at Villa Narcissa at the age of eighty-nine in 2003.

In her later years, Elin lamented what could have been if her husband Kelvin's and her father-in-law Frank A. Vanderlip Sr.'s vision of the Italian-style villages and large estates on the Palos Verdes Peninsula had been realized. Elin passed away at the age of ninety in 2009. Her legacy, as well as that of the entire Vanderlip family, will live on forever on the Palos Verdes Peninsula.

The Peacocks of Palos Verdes

Mr. Vanderlip developed a hobby of maintaining a large bird aviary just below the Cottage that included a number of large bird coops and a large semicircular pond that provided a haven for migratory birds. Mr. Vanderlip also had a full-time bird doctor living next door and a "bird hospital" built next to the pond.

The origin of the peacocks that inhabit the Palos Verdes Peninsula is somewhat disputed. Frank Vanderlip Jr., in an interview, stated that the peacocks were a gift from Lucky Baldwin, a prominent investor and businessman and a friend of Frank Vanderlip Sr. in about 1924. In this

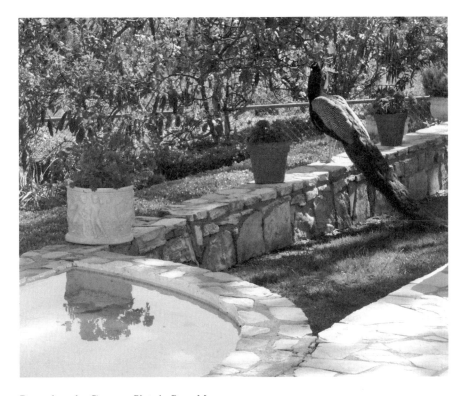

Peacock at the Cottage. *Photo by Bruce Megowan.*

version, Mr. Vanderlip was visiting with Mr. Baldwin at his estate in Arcadia and admired his flock of peacocks that had originally been imported by Mr. Baldwin from India in 1879. Mr. Vanderlip then commented that his Villa Narcissa was "too quiet," and Mr. Baldwin then gave Mr. Vanderlip six peacocks to "liven the place up." Elin Vanderlip, in her book published shortly before her death, also stated that the peacocks were a gift from Lucky Baldwin. This, however, would not have been possible as Mr. Baldwin died in 1909, prior to Mr. Vanderlip's purchase of the Palos Verdes Peninsula.

John Vanderlip, Frank's youngest son, told a similar story to Frank Jr.'s in a 1988 interview with the *Palos Verdes Review* magazine in which he stated that the peacocks came from nine birds provided by Anita Baldwin from the Lucky Baldwin estate in Arcadia as a birthday present for Frank Sr.

Yet another version, published by Francine A. Bradley (PhD, UC-Davis) in a report to the City of Rancho Palos Verdes on managing peafowl on the Palos Verdes Peninsula, states that the original peacock colony on the Palos Verdes Peninsula was a gift of sixteen birds from the daughter of William

Wrigley Jr. to Frank Vanderlip Sr. from Mr. Wrigley's aviary on Catalina Island. This version was supported by an interview with Mrs. John Vanderlip (Suzanne Vanderlip) in 2000. There is a conflict in dates with this story, however. If the peacocks came to the Cottage in Palos Verdes in 1924, as Frank Jr. recollects, the peacocks could not have come from Catalina, as the Wrigleys did not start their aviary until 1927. The most logical story seems to be that the daughter of Lucky Baldwin was the source of the Palos Verdes peacocks. One thing that does not seem to be disputed is that in later years, Mr. Vanderlip's collection of birds (other than the peacocks) was donated back to Mr. Wrigley's aviary on Catalina Island.

The peacocks that had been maintained at the Vanderlip estate in Portuguese Bend were apparently released in Portuguese Bend after Mr. Vanderlip's death. It is suspected that some of the birds were introduced to Palos Verdes Estates by former mayor Fred Roessler sometime in the period from 1960 to 1965. There are now numerous peacock colonies in Rancho Palos Verdes in the Crestridge, Vista Grande and the Portuguese Bend areas, as well as in the Lunada Bay and Malaga Cove areas of Palos Verdes Estates.

Portuguese Bend Landmarks

PORTUGUESE BEND GATEHOUSE—The gatehouse at the entrance gate to the Portuguese Bend community was built by Mr. Vanderlip and was modeled after an Italian roadside chapel used by Michelangelo when he painted the Sistine Chapel. It was initially used to greet potential buyers of lots in the Portuguese Bend area. It has one bedroom, two courtyards (one with a rose garden with a fountain) and a high-ceilinged living room. It is currently occupied and is being beautifully restored by the current owners.

VILLA FRANCESCA GATEHOUSE—Harry Benedict, the personal secretary for Frank Vanderlip, built the Villa Francesca as a gatehouse to the other entrance to the Portuguese Bend gated community on Peppertree Drive. He had planned to build a more palatial estate farther up the hill, but as the Depression hit, he abandoned his plans. In her memoirs, Elin Vanderlip told the story that Frank Vanderlip Sr., while vacationing in Paris, had cabled Mr. Benedict just prior to the 1929 stock market crash to sell his stocks, but Mr. Benedict thought better of it and did not, costing

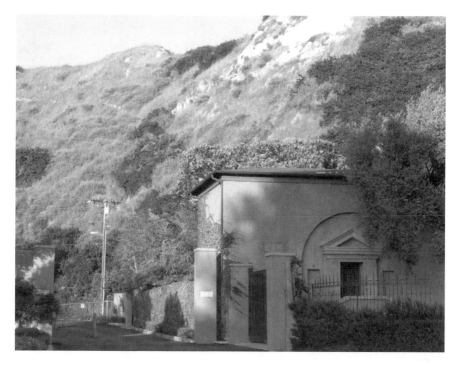

Portuguese Bend gatehouse. *Photo by Bruce Megowan.*

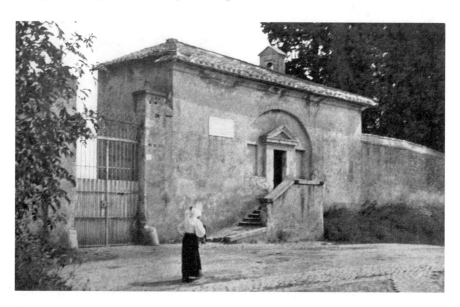

Renaissance roadside chapel in Italy (in 1920) after which the Portuguese Bend gatehouse was modeled. *Courtesy Dan Pinkham from* More Small Italian Villas and Farmhouses *by Guy Lowell (Architectural Book Publishing Company, 1920).*

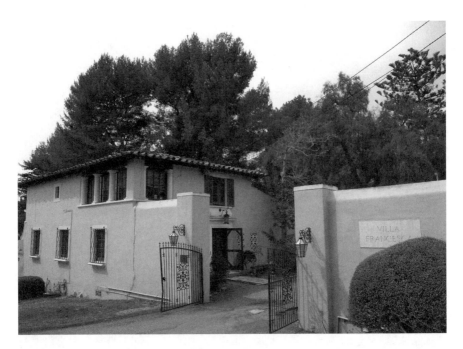

Villa Francesca. *Photo by Bruce Megowan.*

Mr. Vanderlip millions of dollars. Mr. Benedict also had control of the Palos Verdes Corporation from 1943 to 1945; it oversaw the Vanderlip family's remaining ownership of the Palos Verdes Peninsula.

THE HARDEN HOUSE—Across the street from the Portuguese Bend Gatehouse and the entrance to the Portuguese Bend community is a house behind a beautiful gatehouse. This gatehouse was also modeled after one in Italy, the Dovecote building in Ospitaletto, Italy. The house, known as the Harden House, was built by Frank Vanderlip's beloved sister, Ruth, and her husband, Eddie Harden, a business partner of Vanderlip. Vanderlip had given Ruth the forty-eight acres of coastal land on the ocean side of Palos Verdes Drive South as an inducement for her husband to invest in the Palos Verdes Project. They constructed a four-bedroom home with a six-car garage.

They had planned to build a grand villa out on Portuguese Point, but again the Great Depression foiled those plans. Interestingly, the gate entrance to the estate was used in the movie *It's a Mad, Mad, Mad, Mad World* as the entrance to the fictitious "Santa Rosita State Park," and the scene with the crossed palm trees was also filmed on the Harden House grounds. After Ruth died, the Harden House estate was reduced

Harden House gatehouse. *Photo by Bruce Megowan.*

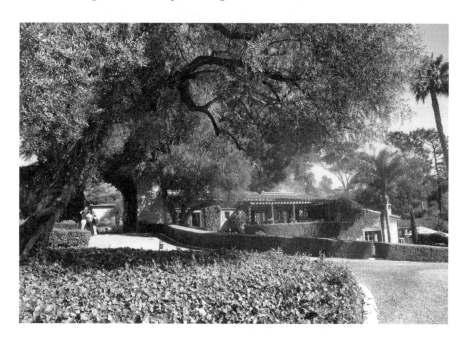

Harden House (gatehouse arch on left). *Photo by Bruce Megowan.*

from forty-eight acres to approximately two, with the balance of the property acquired by the City of Rancho Palos Verdes as the Abalone Cove Shoreline Park.

Portuguese Bend Landslide

Portuguese Bend, in Rancho Palos Verdes, was named for Portuguese whalers who used the cove for a rendezvous and a whaling station. Portuguese Bend was also a smugglers' hideaway. From 1945 to 1956, until a major landslide occurred in the area, the Livingston Quarry operated, mining such minerals as barite, quartz, dolomite and gypsum, as well as the basalt used as railroad bed material. This area is part of the Forrestal Preserve area, which was purchased as a nature preserve in 1996.

In 1956, a 260-acre landslide occurred. The landslide was triggered by roadwork by Los Angeles County road crews that were constructing an extension of Crenshaw Boulevard from Crest Road through Portuguese Bend to Palos Verdes Drive South. About 235,000 tons of dirt that had been excavated for the road was relocated to the top of an ancient but previously dormant landslide. In August 1956, the excavation broke a waterline, and significant land movement began. A number of homes began to slide, and some of the roads had to be rerouted. Some residents gave up and saw their homes go into the ocean; others left the area. About one hundred homes were destroyed and more than fifty damaged, and the Portuguese Bend clubhouse, restaurant and pool were destroyed.

The land in this area has moved more than four hundred feet seaward and continues to creep toward the ocean to this day, requiring constant repair and maintenance of Palos Verdes Drive. A building moratorium still exists in the landslide area. Several homes continue to be occupied in the landslide area, with the homeowners constantly leveling their homes due to land movement by the use of hydraulic jacks.

On October 1, 2008, the California Appeals Court reversed a lower court decision known as the "Monks" case and decided that the landslide building moratorium ordinance of the City of Rancho Palos Verdes for the Portuguese Bend area constituted an unconstitutional "taking" of property and that the city should issue building permits to the seventeen property owners in the lawsuit wishing to build homes in the area. "A permanent ban on home construction cannot be based merely on a fear of personal injury or significant property damage," the jurist concluded

View of the landslide area. *Photo by Bruce Megowan.*

before ordering the case remanded for further proceedings to determine an appropriate remedy.

On October 8, 2008, the city council decided to appeal this decision to the California Supreme Court. On December 17, 2008, the court denied the city's appeal, allowing the seventeen property owners the right to build on their property. The city is currently evaluating whether to extend this right to other property owners in what is referred to as Zone 2 of the landslide area.

Portuguese Bend Club

The Portuguese Bend Club is a private beach colony that has existed since the 1940s. Covering thirty-eight acres with a half mile of coastline, this area was once a haven of summer cottages and small homes built on land leased from Palos Verdes Properties. The leases on the cottages were short, only twenty-five years, because Palos Verdes Properties, owned by the Vanderlip family, was not sure what it wanted to do with the property. They were the typical 1940s weekend places where people went to have a quiet time at

the beach. Back then, there was a clubhouse, a restaurant, paddle tennis courts, a fifty-foot swimming pool, a sandy beach and a 485-foot-long dock where boats could tie up, all of which were destroyed by the Portuguese Bend landslide in the mid-1950s. The restaurant, dock and clubhouse are gone and have been replaced with a volleyball court, paddle tennis courts, playground equipment and, of course, the club's signature palm thatched ramadas and picnic tables.

In the late 1950s, Palos Verdes Properties put forty-two lots up for sale, and they were offered to people who had lost their homes in the landslide. Lot numbers were drawn from a hat, and everybody paid the same price, about $10,000. Some of the buyers moved their houses from the slide area; others built new ones. Beginning in the early 1970s, leases on the properties owned by Palos Verdes Properties began to expire, and the company started to raise the rent. Then, in 1975, the residents of the club united to negotiate the purchase of their properties. These negotiations went on for the next twelve years, and by the end, Portuguese Bend was owned by the Transamerica Corporation.

Purchase of the individual properties from Transamerica was finalized in 1987. At that time, there were fifty-one beachfront homes, and their owners bought their cottage sites, with the Homeowners Association taking title to the beach, the common area (which included nineteen acres), the gatehouse and the roads. No parcel map of the area existed then, only a tax assessor's map, and property was bought on the basis of "what you see is what you get." It wasn't until after the purchase from Transamerica that a survey was conducted to establish lot lines.

There are ninety-four homes in the Portuguese Bend Club. Until recently, homes in the club were on septic tanks, but because the area is so close to the Portuguese Bend slide, city geologists recommended that sewers be installed. Now, all of the homes are hooked up to a private sewer system that has its own sewer pumps and lines.

The club offers year-round membership to about three hundred Peninsula residents.

The Wayfarers Chapel

One of the most notable landmarks in Rancho Palos Verdes is the Wayfarers Chapel, located near Portuguese Bend off Palos Verdes Drive South. This "glass church" was built by the Churches of the New Jerusalem in 1951 as a national monument to Emanuel Swedenborg, an eighteenth-century mystic. The construction was made possible by Mrs. Narcissa Vanderlip,

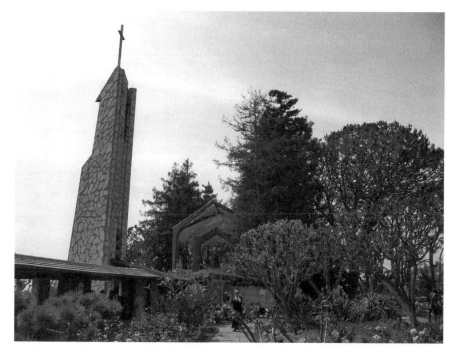

Exterior of Wayfarers Chapel. *Photo by Bruce Megowan.*

who donated the site, and was designed by Lloyd Wright, son of Frank Lloyd Wright.

Peninsula resident and Swedenborgian Church member Elizabeth Sewall Schellenberg first envisioned building such a chapel in the 1920s as a tribute to the church's founder, theologian Emanuel Swedenborg. Mrs. Schellenberg dreamed of a little chapel on a hillside above the Pacific Ocean where wayfarers could stop to rest, meditate and give thanks to God for the wonder and beauty of creation.

Narcissa Cox Vanderlip, also a member of the Swedenborgian Church, responded to the dream and agreed to contribute land for the chapel site. She invited young architect Ralph Jester to draw up plans for the chapel. The Depression of the 1930s and World War II forced a delay in developing the plans.

Following the war, Mr. Jester urged his friend Lloyd Wright to apply his genius to the project. Wright found himself in complete accord with the positive outlook of the Swedenborgian Church and its emphasis on harmony between God's natural world and the inner world of mind and spirit.

Interior of Wayfarers Chapel. *Photo by Bruce Megowan.*

Wright brought the various ideas for the chapel into reality. As with many of Wright's buildings, the chapel features geometric designs and incorporates the natural landscape into the design. This unique structure was specifically designed to serve as a chapel for meditation and prayer for wayfarers, or travelers. Made of redwood, glass and Palos Verdes stone, the building also features numerous triangles, which are intended to symbolize spiritual values. The huge, circular glass panes are also used to convey spiritual concepts.

The three-and-a-half-acre site and the cornerstone were dedicated on July 16, 1949, by Reverend Leonard I. Tafel of Philadelphia, then president of the national Swedenborgian denomination, and the church was completed and rededicated on May 13, 1951.

Today, what you are looking at is not just a glass church but rather a "tree chapel." Lloyd Wright was inspired by the cathedral-like majesty of the redwood trees in northern California. The redwood trees that surround the chapel are forming living walls and the roof. Since its dedication, millions of visitors have toured the Wayfarers Chapel and its surrounding gardens.

Notables married at the Wayfarers Chapel over the years include actress Jayne Mansfield, who married bodybuilder Nicky Hargitay there in January

1958; Beach Boy Brian Wilson; actor Dennis Hopper; astronaut Anna Fisher; and Governor and Mrs. Earl Warren. Other stars spotted there over the years as guests have included Debbie Reynolds, Patricia Nixon, Carroll O'Connor and Bob Hope.

Palos Verdes Landfill

During the early 1900s, the Dicalite Company began mining diatomaceous earth (also known as dicalite) in the area now occupied by the South Coast Botanical Gardens off Crenshaw Boulevard, the former Palos Verdes Landfill site between Hawthorne and Crenshaw and Ernie Howlett Park off Hawthorne Boulevard. At this time, it was mostly surface mining. By 1929, open-pit mining was being pursued. In 1944, the mine operation was sold to the Great Lakes Carbon Company ("Great Lakes"), and mining began in earnest.

By 1956, production of the mine had declined, and the site was sold to the County of Los Angeles, which then converted the site to a sanitary landfill in 1957. On December 31, 1980, the Palos Verdes Landfill officially closed after having accepted a total of 24 million tons of trash since its opening. Partial restoration of the 291-acre site began with the opening of the 83-acre South Coast Botanic Garden on the eastern end of the site in April 1961 and the construction of the 35-acre Ernie Howlett Park on the site's western side, a project fully completed in 1982. The remaining 173-acre site between Hawthorne and Crenshaw, however, still remains unimproved except for some horse stables. Recently, the county had considered constructing a golf course; however, local opposition killed the project.

Butcher Hill. *Photo by Bruce Megowan.*

The area known as Butcher Hill at the southwest corner of Hawthorne Boulevard and Via Valmonte, beginning in 1944—before Hawthorne was extended past the current Via Valmonte in 1965—was part of the dicalite earth mine and extended into the area now occupied by the Hillside Village Shopping Center. This is the last remnant of the dicalite open-pit mining that had taken place on the north side of the Palos Verdes Peninsula.

This land had been leased by Great Lakes from the Vanderlip family, who still owned about 6,800 acres of the original 16,000 acres retained by Frank Vanderlip Sr. when he sold the land that made up the Palos Verdes Project in the early 1920s and later became the city of Palos Verdes Estates. Another rich dicalite deposit was known to exist on a 165-acre tract near the crest of the Peninsula. For two years, Great Lakes had been unsuccessfully attempting to purchase this property from the Vanderlip family. Finally, in a stock transaction in July 1953, Great Lakes purchased all 6,800 acres from the Palos Verdes Corporation, the Vanderlip family's corporation.

The Great Lakes Carbon Corporation, subsequently realizing that this land would be more valuable if developed, then created a master plan for the acreage that later became the cities of Rancho Palos Verdes, Rolling Hills Estates and the unincorporated area known as Palos Verdes Peninsula.

The Development of Rolling Hills Estates and Rancho Palos Verdes

Kelvin Vanderlip, one of Frank A. Vanderlip Sr.'s sons, was president from 1944 to 1951 of the Palos Verdes Corporation, which owned the balance of the Vanderlip family's original sixteen thousand acres of the Palos Verdes Peninsula. After a family dispute in 1951, Frank A. Vanderlip Jr., Kelvin's older brother, was appointed president of the corporation by Narcissa Vanderlip, their mother. Kelvin was dedicated to developing the rest of the family's real estate holdings based on the original vision of his father. He wanted to develop the rest of the Peninsula into large estates, similar to what he had done with Rolling Hills. Frank Jr., however, did not want to sell individual parcels of land, as these profits generated ordinary income for tax purposes that was taxed at very high rates.

Probably the greatest single event that would shape the future of Rancho Palos Verdes and Rolling Hills Estates occurred in 1953. Since 1944, the Great Lakes Carbon Corporation had leased a 300-acre tract of land on the north side

of the Peninsula for mining of diatomaceous earth (the original mine included the current site of the South Bay Botanical Gardens, the former Palos Verdes Landfill and Ernie Howlett Park, and the remnants of this mine can be seen at the southwest intersection of Hawthorne Boulevard and Via Valmonte) from the Vanderlip family. Although this mine's resources had nearly been exhausted, another rich deposit was known to exist on a 165-acre tract near the crest of the Peninsula.

For two years, the Great Lakes Carbon Corporation had been unsuccessfully attempting to purchase this property. Finally, Frank Vanderlip Jr. agreed to sell, provided that Great Lakes purchase all of the stock in the Palos Verdes Corporation for about $9 million so that the sale would be taxed at capital gains rates. Upon completion of the transaction in December 1953, Great Lakes Carbon Corporation suddenly owned 6,800 acres of prime, undeveloped land in the center of the Peninsula— all that was left of the 16,000 acres bought by Frank Vanderlip Sr. from Mr. George Bixby in 1913, with the exception of 500 acres retained by the Vanderlip family in the Portuguese Bend area.

What happened next was not surprising. The plans for mining operations were quickly discarded when it was discovered that the quality of the dicalite deposit was not good, and a group of well-known architects and engineers was hired to create a master plan to develop the property. Great Lakes also formed a 79 percent/21 percent partnership with Capital Company, an experienced real estate firm. In the late 1930s, Capital Company became a subsidiary of Transamerica Corporation and, in 1964, changed its name to Transamerica Development Company.

Fueled by the master plan created by the Great Lakes Carbon Corporation and the burgeoning economic growth occurring in the South Bay area, the remaining unincorporated area on the Peninsula began to develop rapidly and in ever-increasing densities. In September 1955, Palos Verdes Properties Inc. sold the first 117 acres of the 6,800 acres that Great Lakes Carbon Corporation and Transamerica Development had purchased in 1953 to McCarthy Company, land developers. In May 1956, one of the largest land sales took place with Ed Zuckerman and other investors for 1,000 acres, known as Grandview Palos Verdes, located near Montemalaga Drive and Silver Spur Road, for $6 million. The Monaco development of 180 acres was begun in September 1959.

On April 1, 1950, the Palos Verdes Peninsula had about 6,500 residents, and by June 1967, the number of residents had grown to about 54,000. By 1967, only about 1,600 acres remained to be developed.

The Peninsula Center

The area now known as the Peninsula Center on Silver Spur Road in Rolling Hills Estates, today's commercial center of the Palos Verdes Peninsula, has an interesting history. This area was the site of several "work camps" from the early 1930s through the early 1950s.

Mrs. Frank Vanderlip once stated that the wooded hill behind her home in Portuguese Bend was planted in semi-arid trees by the Civilian Conservation Corps (CCC). This camp (Civilian Conservation Corps Camp #2520) was located in the Peninsula Center area. The CCC was established as part of the New Deal during the Great Depression.

Its purpose was twofold: conservation of our natural resources and the salvaging of our young men. The CCC operated from March 1933 to 1942. The CCC planted more than 3 billion trees nationwide during its existence, and many of the trees on the Palos Verdes Peninsula may owe their existence to the work of the young men at this camp. The camp consisted of unemployed young men, many of whom had dropped out of high school. Most camps also included an education center to teach math and reading.

Photo of Civilian Conservation Corps Camp No. 2520, located in the Peninsula Center area. *Courtesy of Bruce Megowan.*

From the early 1900s through 1945, the Peninsula Center area was periodically covered by seasonal lakes. In Elin Vanderlip's memoirs, she stated that the lakes were drained in the 1940s and replaced by a detention camp for prisoners, many of whom were there for missing support payments to their ex-wives. An article from the *Torrance Press* on September 20, 1951, reporting on the opening and dedication of the newly built Crenshaw Boulevard into the Peninsula, stated that "its construction was made possible through use of men quartered at County Detention Camp Number 7, located in the Palos Verdes Hills." The article then went on, quoting Los Angeles County supervisor Raymond V. Darby: "Thus, we have been able to affect a constructive road project and alleviate the County jail of over-crowding." One source noted that this camp was located near the location of the Red Onion restaurant on Silver Spur Road and may have used the camp formerly occupied by the CCC.

The Peninsula Center became the commercial center of the Hill when the original enclosed mall was developed by Ernest Hahn in 1981, adjacent to the existing Peninsula Center Community shopping center. This mall has seen several different owners and names over the years, including the Courtyard Mall, the Shops at Palos Verdes, the Avenue of the Peninsula (when Cousins Properties redeveloped the mall into an open-air center in 1997–98) and today's Promenade of the Peninsula.

The Point Vicente Lighthouse

The Point Vicente Lighthouse is located in Rancho Palos Verdes on the outcropping of land with the same name. Captain George Vancouver, the English explorer, originally named the area Point Vincente in 1790 after the friar of Mission Buenaventura. The name was changed to Point Vicente in 1933.

In 1916, the United States Congress approved the construction of a lighthouse at Point Vicente. Frank Vanderlip Sr., who had acquired the entire Palos Verdes Peninsula in 1913, fought vigorously against this project, as he had planned to construct an artisans' village at this location modeled after an Italian seaside village named Neri. This fight lasted five years, and after the government threatened eminent domain action, the eight-acre site was acquired from Mr. Vanderlip.

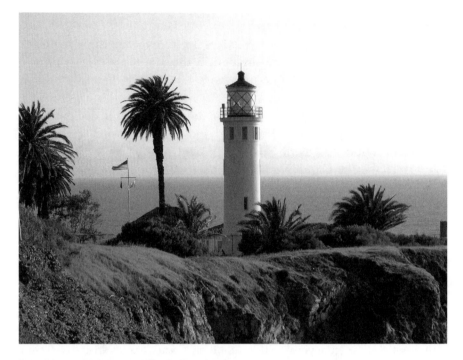

Point Vicente Lighthouse. *Photo by Bruce Megowan.*

The construction of the Point Vicente Lighthouse was completed in 1926 and consisted of seven buildings, now including three houses that function are Coast Guard residences. The most striking feature in the lighthouse is the classical third-order rotating Fresnel lens located in the lantern. The original lighthouse lens was actually created in 1886 in France, and after forty years of service in a lighthouse in Alaska, it was installed at the Point Vicente Lighthouse. The 2-million-candlepower white light is developed from a fifteen-watt bulb focused through the handcrafted five-foot lens. The cylindrical tower is 67 feet tall, and the masonry structure is built on the edge of a 130-foot cliff. This places the center of the lantern 185 feet above the ocean; because of this elevation, the beam can be seen twenty miles away.

For years, there have been rumors that the lighthouse is haunted. After World War II, nearby residents complained about the bright flashes from the lighthouse, and the landward side of the lantern room was painted an opaque, pearly white. The light from the rotating lens seen through the opaque tower room windows created, for some, the illusion of a woman pacing the tower's

walkway and gave rise to Point Vicente's "Lady of the Light," yet another lighthouse ghost story. Some said that the ghost was the spirit of a woman who leapt into the sea when her lover was lost in a shipwreck off the point. In 1955, a thicker coat of paint ended the spirit's nightly romp around the tower, and the ghost has not been seen officially since.

Anton Trittinger was the lighthouse keeper for fifteen years from 1930 to 1945. The U.S. Coast Guard took over operation of the lighthouse from the U.S. Lighthouse Service in 1939. Mr. Trittinger and his family were responsible for the lushly landscaped grounds. The lighthouse has been automated since 1971.

The Point Vicente Lighthouse is open for tours on the second Saturday of each month, except for the month of March, when it is opened on the first Saturday in conjunction with the City of Rancho Palos Verdes's Whale of a Day Festival. The hours run from 10:00 a.m. to 3:00 p.m. PST.

Ocean Trails/Trump National Golf Club

In the 1950s, Edward Zuckerman, with a partner, purchased a sloping 150-acre garbanzo bean field rising up from the cliffs of the ocean on the Palos Verdes Peninsula adjacent to San Pedro. In 1970, Ken Zuckerman's father had tried to build on his farmland 1,200 apartment units, a two-hundred-room resort hotel and a nine-hole golf course. This massive planned development prompted the formation of the city of Rancho Palos Verdes. The new government placed a moratorium on development and then downzoned the Zuckermans' property to require that all new homes be built on one-acre lots. Based on these restrictions, it didn't make sense to build, so the Zuckermans sat on their property until 1989, when Ed Zuckerman's sons, Ken and Bob, with a partner, formed a joint venture for an additional 100 acres or so from developer Barry Hon to accumulate a total of about 260 acres, with close to two miles of ocean frontage.

The Zuckerman family spent years working with the City of Rancho Palos Verdes and various environmental groups to create a plan that would provide native sagebrush habitat for a rare bird, the California gnat-catcher. The plan was initially approved in 1994; however, construction was delayed by years of lawsuits by environmental groups. The Zuckerman brothers created a new limited partnership in 1997, buying out Barry Hon.

Development of the Ocean Trails Golf Course finally began in 1998. Ultimately, out of the Zuckermans' 260 acres, 75 were devoted to seventy-five homesites. The golf course is built on 100 acres (compared to 150 for a typical course), but 20 of those were required to be covered with regrown sagebrush; 105 acres were reserved for sagebrush, public parks or pathways.

Unfortunately, on June 2, 1999, just before its scheduled July 2 opening, a large portion (about seventeen acres) of the cliff-top eighteenth fairway slipped toward the ocean, creating a huge chasm. The project, which had been originally budgeted for $126 million, required another $61 million to repair the landslide damage (paid for by insurance proceeds). For months, the course operated on a temporary basis as a fifteen-hole course.

The property was then tied up in various lawsuits, including a claim by Zuckerman that a waterline running under the property had burst, causing the landslide; however, another potential cause was discovered: an ancient landslide, previously undetected, may have been the cause of this recent disaster.

Trump National Golf Club. *Photo by Bruce Megowan.*

Ultimately, the Zuckermans were forced to declare bankruptcy, and the property was taken over by Credit Suisse, the lender on the property, in February 2002. In August 2002, Donald Trump acquired the Ocean Trails project for a reported $27 million. Subsequently, Trump made substantial improvements. The course was finally opened as an eighteen-hole course on January 20, 2006. Including the money Trump has invested in the course and the original investment by the Zuckerman family, the project has expended in excess of a reported $300 million, clearly making the course the most expensive golf course ever constructed.

Formation of the Cities on the Palos Verdes Peninsula

The Great Depression, which began in 1929, had an extremely debilitating effect on the original unincorporated Palos Verdes Project. Many lot owners defaulted on their property taxes, and the Palos Verdes Homeowners Association, which maintained the project, was in deep financial straits. Notwithstanding that the public properties, including the beach and golf clubs, were devoted to public uses, the land was taxable as private property because it was owned by the Homeowners Association.

By 1938, the Homeowners Association owed the State of California $50,000 for taxes and feared that the state might sell these public properties at a tax sale—the community would lose its most valuable assets. An election was held in December 1939 at which the voters decided to form the city of Palos Verdes Estates to have taxing authority and to solve the financial crisis.

Immediately upon the organization of the city of Palos Verdes Estates in July 1940, all of the parklands, the swimming club and the golf club were transferred to the city, and the back taxes were forgiven by the state. The Miraleste section of the Palos Verdes Project remained unincorporated but subject to the deed restrictions of the Palos Verdes Homeowners Association and the Palos Verdes Art Jury.

The city of Rolling Hills Estates officially became Los Angeles County's sixtieth municipality on September 18, 1957. In that first year, the city's population totaled only 3,500. Annexation of new areas to the city was another ongoing concern during the city's early years. In 1958, areas were added to the eastern and western portions of the city. Later annexations from 1960 to 1966 included numerous recently constructed housing developments. In 1982, the site

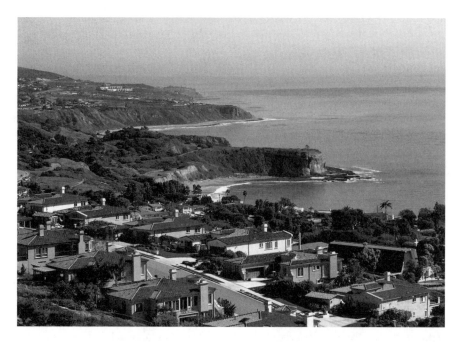

The Rancho Palos Verdes shoreline view that inspired the new City of Rancho Palos Verdes logo. *Photo by Bruce Megowan.*

of the former Palos Verdes Landfill was annexed to ensure that city concerns regarding this closed facility would be recognized.

The city of Rolling Hills was also incorporated in 1957. The Rolling Hills City Hall was constructed in 1967. Rolling Hills is a gated community designed to preserve the equestrian lifestyle.

In 1969, the new county master plan for the remaining unincorporated area of the Peninsula provided for a population density far beyond what the local residents wanted. In response, a Peninsula-wide organization was formed that same year called Save Our Coastline (SOC). After several unsuccessful fights against the county's master plan for the Peninsula, it became evident that the only way to preserve the environment and to gain control over local zoning issues was through incorporation as the city of Rancho Palos Verdes, the fourth city on the Peninsula.

The election to incorporate Rancho Palos Verdes was finally held on August 28, 1973. An overwhelming majority of five to one voted in favor of incorporation.

The first city hall offices were located in the former SOC offices in the Golden Cove Center at the corner of Hawthorne Boulevard and Palos

Verdes Drive West. One of the first actions taken by the new city council was to declare a building moratorium and to begin work on preparing the city's general plan. The city offices eventually moved to the former Nike missile base administrative offices, just above its first offices.

The City of Rolling Hills

The city of Rolling Hills was incorporated in 1957. It is a gated community designed to preserve the equestrian lifestyle. Most of the homes in the city consist primarily of luxury ranch-style homes, and many have been built to accommodate the boarding of horses. The city maintains an extensive system of riding trails throughout the community.

The person most responsible for the character and planning of Rolling Hills was A.E. Hanson, who was the general manager of the Palos Verdes Corporation beginning in March 1931. In 1931, Crest Road was completed, and this gave access to one of the few structures then in existence in Rolling Hills, a run-down abandoned ranch house on the north side of Crest Road that had been originally built in the mid-1880s. Mr. Hanson renovated and expanded this ranch house in the early 1930s for his family and named it Rancho Elastico.

Palos Verdes Corporation's main investor was Frank Vanderlip, and the company owned the balance of the thirteen thousand acres of the Palos Verdes Peninsula that was not part of the Palos Verdes Project (which would later become the city of Palos Verdes Estates and also consisted of the Miraleste area of the city of Rancho Palos Verdes). The Rolling Hills development consisted of about six hundred acres and one hundred homesites.

The first gatehouse for Rolling Hills was constructed in 1935 just off Palos Verdes Drive North. Mr. Hanson dictated that all homes in Rolling Hills would be painted white and that the lots would be fenced in by a three-rail white fence. At this time, there were almost no trees in Rolling Hills, and to promote their planting, Mr. Hanson gave away five olive trees to each purchaser of a homesite in excess of five acres.

In 1939, Mr. Hanson developed the first homes to be sold in Rolling Hills (all previous sales consisting only of land for homes), a development called Williamsburg Lane, which he named after Williamsburg, Virginia. This development consisted of fourteen homes (one and a half acres, three

bedrooms and two baths) that were offered for $8,750. In December 1940, at the depths of the Depression, the Palos Verdes Corporation was deep in debt for unpaid property taxes, and Frank A. Vanderlip Jr., Frank Vanderlip's eldest son who controlled the Palos Verdes Corporation after the elder Mr. Vanderlip's death in 1937, told Mr. Hanson to do whatever was necessary to raise money to pay these taxes. At that time, Mr. Hanson advertised one-acre sites, near the Los Verdes Country Club, for sale for $185; however, he received no takers.

Development of Rolling Hills accelerated when Kelvin Vanderlip, another of Frank Vanderlip Sr.'s sons, was appointed president of the Palos Verdes Corporation after World War II in 1945. To this day, the vision of Mr. Hanson and the Vanderlip family for Rolling Hills has been maintained.

History of the Palos Verdes School System

Before 1925, Palos Verdes school students attended schools in Redondo Beach, which was then part of the Los Angeles City School District. A separate Palos Verdes School District was created in 1925, but only including kindergarten through grade eight. The first school constructed, in 1926 in Malaga Cove, housed all school grades from elementary school through eighth grade, with high school students continuing to attend schools in Redondo Beach. During the construction of Malaga Cove School, students temporarily attended classes in the Gardiner Building in Malaga Cove Plaza.

Palos Verdes High School was originally planned and constructed as a six-year school for grades seven through twelve by the Los Angeles School District in 1960, but when the Palos Verdes Peninsula Unified School District (PVPUSD) was formed to include high schools as well as grade school students, the partially completed campus of Palos Verdes High was converted to a high school in 1961—the first high school of the unified school district. When the school opened, construction was not complete. Some classes had to be held in the lunch area, and others met in the school buses. (PVPUSD owned a large fleet of yellow school buses at that time.) Originally, the school had a print shop and an auto shop, but both were never used for those purposes.

Before the opening of Palos Verdes High School, high school students on the Peninsula attended such schools as Redondo Union High and

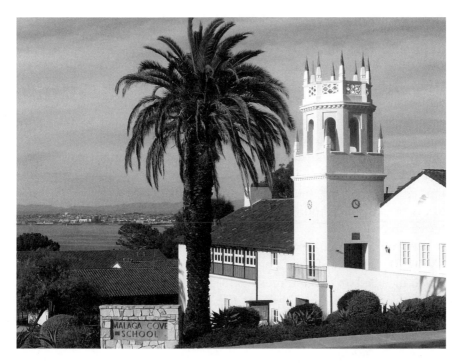

Malaga Cove School. *Photo by Bruce Megowan.*

Narbonne High. Rolling Hills High School opened in the fall of 1964 for grades nine through eleven. Seniors stayed at Palos Verdes High School. Miraleste High opened in 1968.

In 1991, due to declining high school enrollment, the three high schools were consolidated on the campus of Rolling Hills High School and renamed Palos Verdes Peninsula High School. "Peninsula High School" was the name that was supposed to have been given to the fourth high school that had originally been planned to be built on thirty-five acres across Highridge Road from Ridgecrest Intermediate School. However, that school was never built, ten acres were developed as Highridge Park and twenty-five acres were sold for $6 million to a developer in 1986 (which caused quite a furor since many thought it was below market value). When the "consolidated" high school was named, then, it got the Peninsula High name.

At the time of consolidation, Palos Verdes High and Miraleste High were converted to intermediate schools, and the former intermediate schools at Malaga Cove and Margate were closed and temporarily leased to other preschools and prep schools. When Palos Verdes High School was reopened

in 2002 (with just freshman and sophomores), the school at Margate was reopened as Palos Verdes Intermediate School, and Ridgecrest Intermediate School was converted from an elementary school site soon after. Palos Verdes High School and Peninsula High School are open-enrollment schools—any student in the district may attend either high school.

In 1983, the unincorporated area of Eastview adjacent to San Pedro was annexed to the city of Rancho Palos Verdes, but there were no changes made to school district boundaries. Eastview remained in the Los Angeles Unified School District (LAUSD). During the years from 1983 through at least 1995, the LAUSD opposed all attempts of the PVPUSD to revise its district boundaries to include Eastview. In 1991, the entire board of education for PVPUSD signed Resolution 16, supporting the territory transfer for the Eastview area from LAUSD to PVPUSD. PVPUSD was successful in using the school district reorganization process, which included an election in which 84 percent of the Eastview residents approved the transfer. However, the process failed when the courts determined that the election was invalid since it did not include residents of the LAUSD. Ultimately, California state law SB 1681 made Eastview an optional attendance area in 1999.

Those students who live in the Eastview area have a onetime election to enroll in either the Palos Verdes School District (attending Dapplygray Elementary and Miraleste Intermediate) or the Los Angeles Unified School District (Dodson Middle School and Crestwood Elementary School).

Palos Verdes in the 1940s

When World War II began, the residents of the Palos Verdes Peninsula banded together to support the war effort. Many of the residents of the Palos Verdes Peninsula volunteered to be spotters posted at various locations looking for enemy activity, and block wardens saw the need for closer relationships with residents. In July 1942, these men began to meet on Saturday mornings, and the Palos Verdes Breakfast Club was formed. It has remained active for seventy years.

One of the first military defensive positions was established at the Haggarty estate in Malaga Cove. Battery installations were installed at the current location of the Rancho Palos Verdes City Hall, as well as at Rocky Point in Lunada Bay in 1943, that included two sixteen-inch guns. Barracks and support buildings were also constructed in Lunada Bay. An underground

observation point was constructed at Punta Place overlooking Bluff Cove and the South Bay.

Unfortunately, one of the early activities of the war was the internment of many of the Japanese farmers and their families who had lived on the Peninsula for years.

There were air raid warnings, most of which were false of course, but Lieutenant Richard Throne wrote about the "Battle of Los Angeles" as follows:

> *One other event took place on Christmas 1941 when what was thought to be a Japanese submarine was sighted off of Redondo Beach. The Air Corps and Navy responded and dropped several bombs. The only thing sunk was the old fishing barge that was anchored off the coast. What was left of the barge washed ashore on the beach at Malaga Cove. It was quite an attraction for some time and a number of its parts were salvaged by local boys.*

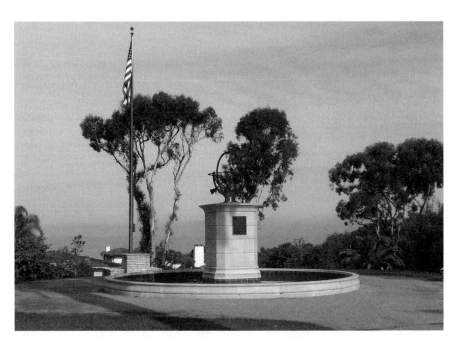

The Palos Verdes Memorial Garden, located across from city hall in Malaga Cove, was rededicated in 1996. Originally dedicated in 1947 to John Bleecker, Hammond Sadler and Morris Shipley, who lost their lives in World War II, the garden now honors all members of the armed services and local police who have lost their lives in the line of duty. *Photo by Bruce Megowan.*

The Palos Verdes Peninsula population grew rapidly after World War II. In 1946, construction began on several housing tracts in Hollywood Riviera. The best route for construction trucks at the time was up Hawthorne Boulevard, which at that time did not go all the way up the hill to the top of the Peninsula but instead veered to the right at Via Valmonte (which was then Hawthorne Avenue, originally named Via Mirlo) and ended at the Palos Verdes Country Club.

The residents of the Valmonte area of Palos Verdes Estates were so irritated and inconvenienced by the large amount of traffic of dump trucks, bulldozers and more traveling to the Hollywood Riviera housing tracts that they prevailed on the city council of Palos Verdes Estates in 1948 to construct barriers in the middle of Via Alameda, Via Pasqual and Via Colusa just inside the PVE city limits. They've been there ever since.

History of Marineland of the Pacific

Marineland of the Pacific, which opened in 1954, provided the primary tourist attraction in Rancho Palos Verdes for many years. The attractions of Marineland included the 320-foot Skytower; the splashy acrobatics of the killer whales Orky and Corky and Bubbles the pilot whale; and snorkeling along the curved, faux-rocky recesses of Baja Reef. Marineland was only the second oceanarium in the United States when it opened to the public on August 28, 1954. The first was Marine Studios in Florida.

Marineland's first owner, Oceanarium Inc., owned by Henry Harris, hoped to capitalize on that popularity. On the cliffs overlooking the ocean, his team built two enormous oceanarium tanks—both three stories tall—a restaurant, a twelve-unit motel, offices and laboratories. On the beach below, they built a 250-foot-long pier to help bring in the animals.

In 1957, they caught Bubbles, a twelve-foot-long, 1,600-pound female pilot whale—the first ever caught and kept alive in captivity. Ticket sales went through the roof. The craze boosted ticket sales past 1 million that year, which allowed owners to build a $500,000 sea lion and dolphin stadium in 1958. Bubbles was eventually joined by other pilot whales named Squirt and Bimbo.

Sea Hunt, a television series that ran from 1958 to 1961 and starring Lloyd Bridges as Mike Nelson, was initially filmed primarily at Marineland. In fact, the show's character of Mike Nelson was an ex-

navy frogman employed by Marineland. But over time, as Disneyland opened in 1955 and SeaWorld San Diego was built in 1964, the theme park competition took a toll on Marineland, and attendance plateaued. Still, park owners continued to add more new attractions. The Skytower was erected in 1966.

The park got a boost in 1968 when it captured Orky, its first killer whale, which was soon joined by Corky. But by the early 1970s, the competition was getting fiercer, and ticket sales were dwindling. Marineland's original shareholders brought in 20th Century Fox as park operators. The park was then sold in 1978 to the owners of Hollywood Park in Inglewood. Soon 20th Century Fox pulled out as operator of the park, and Hollywood Park brought in Hanna-Barbera as park operator.

The enactment of the Marine Protection Act of 1972 also made it illegal to capture any new animals from the wild, so the park and others like it expanded their breeding programs. Eventually, the costs associated with the park's breeding program and marine animal-care center were outweighing ticket sales.

Marineland was closed in December 1986 when Harcourt Brace Jovanovich, which owned SeaWorld in San Diego, purchased Marineland, ostensibly to continue to operate it. After moving the killer whales in the middle of the night with no notice, the park abruptly closed in February 1987.

Why Did Marineland Close?

In 1986, Harcourt Brace Jovanovich, the publishing giant that then owned SeaWorld in San Diego, was in the process of rapidly expanding the SeaWorld enterprise throughout the nation and was in desperate need of proven, successful breeding pairs of killer whales in order to supply its new SeaWorld locations with its headline act, "Shamu, the Killer Whale." Harcourt had been denied a permit to capture additional killer whales in the wild and was therefore limited to acquiring killer whales already in captivity. Harcourt approached the owners of Marineland, which was then struggling financially, with an offer to purchase its star attractions, Corky and Orky, which had proven to be a successful breeding pair. The owners of Marineland were unwilling to part with them and instead offered to sell the entire Marineland park.

In public testimony to the city council of Rancho Palos Verdes, company officials stated that their intentions in acquiring the park were to renovate and keep the park open. They really only wanted Orky and Corky, however, and planned to shut the park down and immediately sell the land to an Arizona developer. They quickly did just that after closing the park. Harcourt completed its purchase of the park in late 1986 and, within a few weeks after the purchase, moved Corky and Orky to its SeaWorld Park in San Diego in the middle of the night without any prior notice to the public. It then closed Marineland, claiming that the park was going to cost more money to renovate than it originally estimated.

Unfortunately, Orky, the male, died two years later in 1988. However, Corky is still alive (she is now believed to be about fifty years old and the oldest of the seven killer whales in San Diego) and performing daily at SeaWorld in San Diego. She gave birth to seven calves; however, all died soon after birth, with the oldest living only for forty-six days. Palos Verdes residents, to this day, mourn the loss of this wonderful community asset that, fortunately, has been replaced by the beautiful new five-star Terranea Resort.

Wallace Ranch

Don Wallace, a ham radio pioneer who had worked as an amateur radio operator since 1913, operated W6AM as a ham radio operation from his land atop the Palos Verdes Peninsula at the junction of Armaga Springs Road and Highridge Road in Rolling Hills Estates. His antennae farm included a huge installation of rhombic antennae, each perched on a telephone pole, some more than 150 feet tall. The site was originally acquired in the 1930s by Press-Wireless, owned by a group of newspapers, to receive news dispatches from around the world. During World War II, the U.S. War Department used the facilities to communicate with battle operations in the Pacific, relayed to Pearl Harbor. In 1942, William Arthur Schuler, twenty-three, who lived in Palos Verdes Estates and worked for Press-Wireless, was arrested by the Federal Bureau of Investigation for spying. He had offered to transmit messages to foreign agents using the Press-Wireless transmitters. He got six years in a federal penitentiary.

In 1945, Don Wallace bought the land from Kelvin Vanderlip, president of the Palos Verdes Corporation who, in order to control deed restrictions, had bought the land from Press-Wireless. The station in

1945 had 120 acres of land with sixteen rhombic antennae, the longest being 1,500 feet (end to end). This 1,500-foot rhombic is widely believed to have been the largest beam antenna ever in amateur service. He had sixty-one telephone poles, each at 80 feet, and another ninety feed line poles (25 feet high each). These antennae were fed by fifty-two *miles* of feed lines.

In 1962, Don had to sell ninety-five of the acres to pay the property taxes, and he collected the grand sum of $100,000 for the acres. Don then consolidated his antennae. He continued to operate his radio station until his death in 1986, whereupon his family sold the land to real estate developers. The land that Mr. Wallace owned is today several condominium and luxury home developments, including the Ranch.

In 1960, General Telephone and Great Lakes Property Inc. proposed a four-hundred-acre "campus like science center" near the intersection of Hawthorne Boulevard and Crest Road just down the road from the Wallace antennae farm.

The first tenant was the Nortronics division of Northrop Corporation, which planned a 100-acre development. Great Lakes Property Inc., after no other companies followed Northrop's interest in the property, announced that it would sell 107 acres of land as a site for what was then being called Palos Verdes State College. This sale was never completed, and the new college became Cal State Dominquez. Gradually, the balance of the land originally planned for the Palos Verdes Research Park was parceled off and sold for home development. In 1991, Northrop decided to sell its 34 acres that it still occupied, and this land was later developed into the Vantage Point subdivision.

Chandler Quarry and the Chandler Ranch Project

The ninety-one-acre Chandler Sand and Gravel Quarry, located on Palos Verdes Drive East between Palos Verdes Drive North and Pacific Coast Highway, opened in 1934. The quarry was originally owned by the Portland Cement Company. Shortly after forming his own trucking company in 1939, Linden Harold Chandler bought five acres of land in the quarry, and in 1945, he was able to purchase the gravel pit and six hundred additional acres of land for $1 million. The family accumulated a large amount of landholdings in the South Bay, part of which the family donated in 1993 to

create the twenty-eight-acre Linden H. Chandler Nature Preserve. Linden Chandler died on April 14, 1995.

Several proposals have been made over the years to recycle the quarry, which is currently used to store inert construction materials. In the late 1960s, a proposal was made to fill in the quarry and construct a regional park; however, that proposal was finally defeated in 1974. In 1971, a developer proposed building about three thousand apartments and townhouses on the property. In 1972, another proposal was made that would mix single-family homes, townhouses and commercial and recreational facilities not to exceed 750 unites on 125 acres of Chandler property. As far back as 1978, Cayman Development Company had been in discussions with the Rolling Hills Country Club adjacent to the quarry to expand the golf course and to build single-family homes.

The current proposed project by the owners of the quarry consists of redeveloping/reusing 228 acres of the existing Chandler's Palos Verdes Sand and Gravel facility (Chandler's) and the adjacent Rolling Hills Country Club (RHCC) into the following: 114 single-family homes, 113 of which would be within a new 62-acre residential community; a reconfigured/relocated eighteen-hole golf course; a new clubhouse complex that would include a 61,411-square-foot structure; and 3.9 acres set aside as natural open space. RHCC currently leases about two-thirds of the existing golf course from Chandler. The lease expires in July 2022, and RHCC has no renewal right. The plan requires the approval of an approximately 32-acre annexation/deannexation between the cities of Rolling Hills Estates and Torrance to allow for all residential development to be located within the city of Rolling Hills Estates, with golf course and open space use in the city of Torrance. At this time, students in the residential area would attend the Palos Verdes, Torrance or Los Angeles Unified School Districts.

On July 26, 2011, the Rolling Hills Estates City Council certified the plan's Environmental Impact Report and approved a tentative map for the new tract, along with various permits and a grading plan. The approval includes a requirement for the developer to donate $1 million (to be matched by developer fees) for equestrian activities in Rolling Hills Estates. The city has a ten-year development agreement with Chandler's, and Chandler's continues to work to move the project forward.

SOUTH BAY HISTORY TALES

Early European Exploration of the South Bay

Portuguese explorer Juan Rodriguez Cabrillo, while sailing under the flag of Spain, was the first European to set eyes on the barren hills and plains of what was to be Rancho San Pedro. He is believed to be the first European to explore the California coast. He was either of Portuguese or Spanish background, although his origins remain unclear. In June 1542, Cabrillo led an expedition in two ships of his own design and construction from the west coast of what is now Mexico. He landed on September 28 at San Diego Bay, claiming what he thought was the Island of California for Spain.

Cabrillo and his crew landed on San Miguel Island, one of the Channel Islands, and then continued north in an attempt to discover a supposed coastal route to the mainland of Asia.

On October 8, 1542, he sailed into San Pedro Bay. There he noticed several wild fires burning in the surrounding hills, producing dark plumes of smoke. He named the area *Bahia de los Fumos*, Spanish for "Bay of Smokes." This bay with a shallow estuary held this title for more than fifty years, until changed by another Spanish sea-faring explorer. On November 26, 1602, Sebastian Viscaino sailed into the same bay and renamed it *Ensenada de San Andres* (Bay of St. Andrew), mistakenly thinking that he arrived on the feast day of St. Andrew. In 1734, Cabrera Bueno, a famed navigator and cosmologist, discovered Viscaino's error and renamed the bay San Pedro, in honor of the martyred saint.

Two points along the coast bear very old names. In 1793, Captain George Vancouver, who had been commissioned by King George III of England to explore and chart the Pacific Coast, sighted a "very conspicuous promontory." He named it Point Vincente, after the friar Padre Vincente Santa Maria stationed at the Mission San Buenaventura. The spelling of the name was revised from Vincente to Vicente in the mid-1920s. (The U.S. government established a lighthouse on Point Vicente in 1875, and the present structure was built in 1926.) Sailing a little farther south along the coast, Vancouver came to a second point, which he named Point Fermin in honor of Padre Fermin Francisco de Lausen, head of all the California missions.

The vessels that traded at San Pedro anchored at a point on the northwest side of San Pedro, slightly northeast of Point Fermin, off the coast of Rancho Palos Verdes. Although later known as Timms' Point, this anchorage was first called Sepulveda Landing. Between Point Fermin and Point Vicente lies Portuguese Bend, named for Portuguese whalers who used the cove for a rendezvous and a whaling station. Portuguese Bend was also a smugglers' hideaway. Spain limited the number of ships that could dock in San Pedro and exacted stiff fines, including forfeiture of property and death to those who violated the edict.

Rancho San Pedro

Rancho San Pedro Land Grant

The land that includes the entire Palos Verdes Peninsula, San Pedro, Torrance, Redondo Beach and Hermosa Beach was part of the first Spanish land grant in California. Juan Jose Dominquez, a member of the 1769 Spanish Portolà Expedition helped protect Junipero Serra and other Franciscan padres who established a chain of missions from San Diego to Sonoma.

Due to Dominguez's many years of dedicated service to the king of Spain, Governor Fages bestowed a provisional grant to the retired old soldier in March 1784, allowing him to graze his cattle on Rancho San Pedro. These original land grants were not considered at the time to be a permanent ownership interest but were instead merely considered a permit to use the land and occupy it. This was the first private land grant in Southern California.

The boundaries of this original land grant have been a controversial subject among historians, with most stating that the Rancho San Pedro

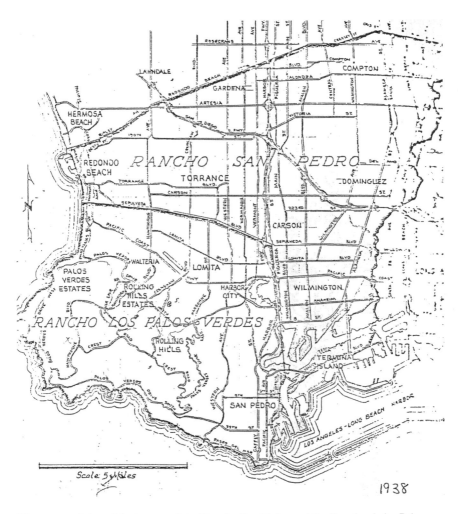

The extent of the original grant of the Rancho San Pedro and the Rancho de los Palos Verdes, with present-day city boundaries and streets (note that the eastern boundary was probably the original path of the Los Angeles River). *Historical Perspective Rancho San Pedro to Lot 49-Section 7 Ownership & Land Use, by William R. Jankowiak, 1977; map provided by Jack Moffett.*

consisted of about seventy-five thousand acres, with the northern boundary of Rancho San Pedro extending in a southwesterly direction to the ocean at a point between Redondo Beach and Hermosa Beach.

After the death of Juan Jose in 1809, Manuel Gutierrez, who had been the ranch manager of the Dominquez Ranch, became the executor of Juan Jose's estate. In his will, drawn up three days before his death, he left half of

Rancho San Pedro to Cristobal Dominguez, and the other half was divided between Mateo Rubio, who had been in charge of ranch operations, and Gutierrez—Juan Jose Dominguez had no wife or children.

When Cristobal realized that his uncle died in debt and neglected his rancho, he initially wanted no part of his inheritance. He had no money to pay his uncle's creditors and could not occupy the rancho even if he wanted to because he was still obligated to the military. In fact, he did not even attempt to defend his title to the land for seven years. Gutierrez paid off the debts owed by Juan Jose Dominguez, established residence and assumed control of the rancho.

Sepulveda versus Dominquez

Shortly after Manuel Gutierrez assumed operating control over Rancho San Pedro in 1809, Gutierrez allowed a friend, Jose Dolores Sepulveda (also sometimes referred to as Don Jose Sepulveda), to graze a thousand head of cattle in the southwest portion of the property known as Canada de Los Palos Verdes (Canyon of the Green Trees). Sepulveda built an adobe home here and made significant improvements to the unused portion of the land. Sepulveda's adobe home (Registered California Landmark No. 383) is located in the Walteria section of Torrance, at Madison Street and Courtney Way.

Cristobal Dominguez, who claimed ownership of the Rancho San Pedro but had not done anything to defend his title for seven years, was upset with the arrangement Gutierrez made with Sepulveda when he found out about it and protested. It was assumed by Gutierrez that Dominguez had abandoned his claim to the rancho and that Gutierrez had every right to give young Jose Dolores Sepulveda permission to use the land.

In August 1817, Cristobal Dominguez finally filed a petition with Governor Pablo Vicente de Sola to have Sepulveda removed from the property and requested that Rancho San Pedro be fully granted to him by eliminating the ownership rights of Gutierrez. Gutierrez and Sepulveda refused to give up the land they worked so hard to improve. The governor issued a short, poignant decree ordering Sepulveda from the rancho and granting provisional ownership to Cristobal Dominguez. Sepulveda refused to relinquish his home and appealed the governor's decree. After receiving title to Rancho San Pedro, Dominguez remained in San Diego and never even visited the rancho.

On December 31, 1822, shortly after Mexico had gained its independence from Spain, Governor Sola formalized the land grant by confirming Cristobal Dominguez as owner of Rancho San Pedro. This was just the beginning, however, of a twenty-four-year fight between the Sepulveda and Dominquez families over ownership of the rancho.

The Fight for Rancho Los Palos Verdes

After the 1822 decree by the governor of California that awarded ownership of Rancho San Pedro to the Dominquez family, Jose Dolores Sepulveda appealed the decision and requested a personal meeting with Governor Luis Arguello in Monterey to plead his case. In 1824, while Sepulveda was returning from his trip to Monterey, he was killed in a violent Indian uprising at Mission La Purisima Concepcion, near today's Lompoc.

His young sons, Juan Capistrano Sepulveda and Jose Loreto Sepulveda, continued his quest for Rancho San Pedro. On May 16, 1826, after the death of his father in 1825, Manuel Dominguez filed a petition with Governor Jose Maria Echeandia to have the Sepulveda brothers and their cattle removed from the Palos Verdes portion of the rancho. On May 26, 1826, the heirs of Cristobal Dominguez were confirmed by the governor as owners of Rancho San Pedro, thus being officially recognized by the new Mexican regime. Known for his administrative ineptness, Governor Echeandia also provisionally approved of the Sepulvedas' claim to the Palos Verdes portion of Rancho San Pedro in 1827.

In 1834, a judicial decree was made by Governor Jose Figueroa that was intended to settle the dispute between the Dominquez and Sepulveda families, and Juan Capistrano Sepulveda and Jose Loreto Sepulveda were awarded the 31,629-acre Rancho Los Palos Verdes. The partition decree left the Dominguez family with 43,119 acres, reducing Rancho San Pedro by nearly half the area of the original grant.

The Sepulvedas were given yet another order to leave the Palos Verdes section of Rancho San Pedro in June 1839. Again, the Sepulvedas defended their title, and on April 22, 1841, they received a Decree of Possession and an additional strip of land north of Palos Verdes Hills from Governor Alverado. In June 1841, an agreement was signed by the Dominquez family transferring all right to the Rancho Los Palos Verdes to the Sepulvedas. Then, on June 3, 1846, Governor Pio Pico officially confirmed the title of Rancho Los Palos Verdes to the two oldest Sepulveda brothers.

Juan Capistrano Sepulveda built his adobe home near the intersection of Gaffey and Anaheim Streets in San Pedro. Jose Loreto Sepulveda built his home farther south on the west side of North Gaffey Street between Channel Street and Anaheim Street in San Pedro. Jose Loreto Sepulveda was also second alcalde of Los Angeles, which was basically vice-mayor of Los Angeles, for four years during the period between 1837 and 1848. Juan Capistrano Sepulveda was also second alcalde of Los Angeles in 1845.

The Mexican–American War and the South Bay

On the morning of August 6, 1846, Juan and Jose Sepulveda were at the Port of San Pedro, spotted an American warship and sent word to the local Mexican army. This ship, commanded by Commodore Robert Stockton, had been sent to San Pedro by President Polk to seize California in the name of the United States after hostilities had begun with Mexico on April 25, 1846. On August 11, Stockton began to march his troops from San Pedro to the pueblo Los Angeles. The local Mexican soldiers, unprepared to defend the city, fled to Mexico, and on August 13, Stockton rode into Los Angeles without firing a shot.

Stockton, returning to Monterey, left Lieutenant Gillespie in charge of Los Angeles. Gillespie proved to be particularly unsuited to command the city, and after issuing a number of very draconian measures, including limiting the right of more than two people to meet together and arresting several important citizens for questioning, the people of Los Angeles rose up in rebellion.

On October 6, the frigate *Savannah* arrived with reinforcements. Juan Sepulveda, in charge of a forty-five-man patrol, saw the arrival of the American warship and sent word to other Californians. The Californians repeatedly attacked the advancing American column, and after a particularly devastating cannon attack, the Americans again retreated to the *Savannah* in San Pedro Harbor. The Americans buried their dead on Deadman's Island in the harbor and waited for reinforcements.

On October 23, the *Congress* sailed into San Pedro Harbor with Commodore Stockton and reinforcements. The Californian forces created an illusion of having many more men than they actually had by riding in a circle single file through a gap in the trees in a hill overlooking the harbor and by dragging brush to kick up dust. Stockton, thinking that he was facing a force of at least eight hundred men, panicked and immediately

set sail for San Diego. The war was far from over, however, as a land force led by Colonel Stephen Kearney was moving across the continent toward California. Kearney succeeded in reaching Stockton in San Diego, and on December 29, their combined force of nearly six hundred men marched up the coast toward Los Angeles.

On the morning of January 9, 1847, a bloody battle took place overlooking the San Gabriel River, near present-day Montebello, between the Californians and the Americans. During the battle, young Ygnacio Sepulveda, the brother of Juan and Jose Sepulveda, was killed. The next morning, the triumphant American forces marched into downtown Los Angeles.

On January 11, John C. Fremont's men reached the San Fernando Valley, and when Andres Pico, leader of the Californian forces, surrendered his sword in a Cahuenga rancho house, California's participation in the Mexican-American war came to an end. On February 2, 1848, the Treaty of Guadalupe Hidalgo was signed annexing California to the United States.

Palos Verdes and South Bay Japanese Farmers

When land values dictated that Peninsula property could no longer be used for only cattle grazing, George Bixby leased the land to Japanese farmers to cultivate fruits and vegetables. Land was leased for about ten dollars per acre, and by the early 1900s, nearly forty Japanese families were cultivating crops on the Peninsula. The Ishibashi family was one of the first Japanese families to farm the Peninsula.

Kumekichi Ishibashi came to San Francisco in 1895 and walked to Los Angeles. He worked as a houseboy for many years, but in 1906, he leased his first farm from Bixby in 1906 at the site of the present-day Trump National Golf Club in Rancho Palos Verdes. In 1910, Kumekichi brought his younger brother, Tomizo, to join him at the farm. The Ishibashi family used to get water once a week for their house, which they built themselves, from a well in the Portuguese Bend area; this took the better part of a day. The family farmed by the "dry farming" method with no irrigation and grew beans, cucumbers, peas and tomatoes. Early electricity was obtained by a boat generator and auto batteries.

When World War II began, however, the Japanese families who were farming the Rancho Palos Verdes area were interned for the duration; many were relocated to the internment camp at Manzanar, California. On February 1, 1942, Kumekuchi Ishibashi and his wife, Take, were taken to

a detention camp for Japanese in Bismarck, North Dakota. In July 1942, Kumekuchi's family—including his son Mas; Mas's wife, Miye; their son Satoshi, who was seven years old at the time; and two of Mas's brothers, George and Aki—were interned at Poston, Arizona. In a little over one year, Kumekichi was able to reunite with his family in Poston. They then moved to Utah to farm for the duration of the war. Two of Mas's brothers, George and Kay served in the 442nd Regimental Infantry Combat Unit. This unit received more citations than any other outfit of its size.

Miye Ishibashi sold strawberries on the side of the road, and Mas farmed Rancho Palos Verdes for more than fifty years, with the exception of the internment years. Their son, Satoshi, continued working with his father to farm rolling acres of barley and garbanzo beans for many of those years as well.

Tomizo, Kumekichi's brother, had four farming sons—Ichiro, James, Tom and Daniel—as well as two daughters, Yukiko and Naomi. James Ishibashi's farm was located next to the entrance to Portuguese Bend, and he also farmed land on the current Trump National Golf Course. His wife, Annie, sold vegetables at "Annie's Stand," serving the community for forty years. James died in 2002, and his family home and farm in Portuguese Bend was sold in 2011. Tom Ishibashi, who had farmed on city-owned property next to Torrance Municipal Airport since the early 1960s, died in May 2011 at the age of eighty-two, and the family farm closed in March 2012.

The Partitioning of Rancho Los Palos Verdes

Beginning in 1840, the Sepulveda family—consisting of Juan Capistrano Sepulveda and Jose Loreto Sepulveda, the two oldest surviving sons of Jose Diego Sepulveda who had grazed cattle on the Rancho Los Palos Verdes since 1809 and had won a Spanish land grant for the rancho; two younger brothers Jose Diego Sepulveda and Ygnacio Rafael Sepulveda; and their sister Maria Teresa Sepulveda—began to sell or mortgage a large portion of their interest in the rancho. In July 1840, Ygnacio Sepulveda surrendered his 20 percent interest to his brother-in-law, Nathaniel Pryor, for fifty dollars.

During the ten-year period from 1855 to 1865, the Sepulvedas faced significant financial difficulties, including a severe drought in 1862–64 that wiped out most of their cattle herd. During this time, the family began to incur significant debt.

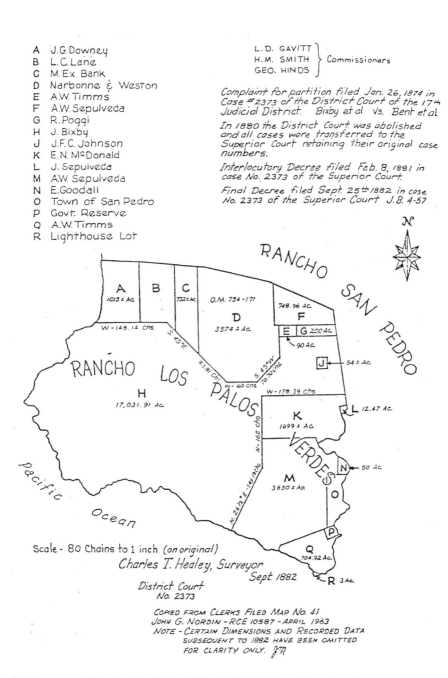

A J.G. Downey
B L.C. Lane
C M. Ex. Bank
D Narbonne & Weston
E A.W. Timms
F A.W. Sepulveda
G R. Poggi
H J. Bixby
J J.F.C. Johnson
K E.N. McDonald
L J. Sepulveda
M A.W. Sepulveda
N E. Goodall
O Town of San Pedro
P Govt. Reserve
Q A.W. Timms
R Lighthouse Lot

L.D. GAVITT
H.M. SMITH
GEO. HINDS } Commissioners

Complaint for partition filed Jan. 26, 1874 in Case #2373 of the District Court of the 17th Judicial District. Bixby et al vs. Bent et al

In 1880 the District Court was abolished and all cases were transferred to the Superior Court retaining their original case numbers.

Interlocutory Decree filed Feb. 8, 1891 in case No. 2373 of the Superior Court.

Final Decree filed Sept. 25th 1882 in case No. 2373 of the Superior Court J.B. 4-57

Scale - 80 Chains to 1 inch (on original)
Charles T. Healey, Surveyor
Sept. 1882
District Court
No. 2373

COPIED FROM CLERKS FILED MAP No. 41
JOHN G. NORDIN - RCE 10587 - APRIL 1963
NOTE - CERTAIN DIMENSIONS AND RECORDED DATA SUBSEQUENT TO 1882 HAVE BEEN OMITTED FOR CLARITY ONLY.

Partition map of Rancho San Pedro, 1882, for District Court Case 2375. *Illustrated in Historical Perspective Rancho San Pedro to Lot 49-Section 7 Ownership & Land Use, by William R. Jankowiak, 1977.*

In 1855, Juan Capistrano Sepulveda mortgaged his 20 percent share of the rancho, which then went into foreclosure, but it was purchased for $3,000 in 1858 by Jose Diego Sepulveda, Juan's younger brother, who had previously sold his 20 percent interest in the rancho in 1849 to a man named Santiego Johnson. In 1855, Jose then deeded twelve acres of land back to his older brother.

In 1869, Jose Diego Sepulveda died and left his 20 percent interest in the rancho to his sons. Narbonne and Weston, two sheep herders, bought a 10 percent interest in the rancho from Jose Loreto Sepulveda for $4,000 in 1872.

In December 1872, Jotham Bixby bought the 20 percent interest in the rancho claimed by Maria Sepulveda. In August 1874, Jose Loreto Sepulveda mortgaged his remaining 15 percent interest in the rancho, which was foreclosed on in 1879 and then purchased by Jotham Bixby. In 1874, Bixby purchased the 20 percent interest in the rancho claimed by Santiego Johnson's heirs at a public auction. This brought Bixby's total interest in the rancho to about 45 percent. During these years, Bixby made additional purchases of a portion of the rancho.

Numerous additional lawsuits were filed in the mid-1870s disputing ownership of the land making up the rancho, due to parties sometimes buying or selling the same claimed interest and requesting partitioning of the land. During the period between 1865 and 1880, the Sepulvedas were engaged in seventy-eight lawsuits, six land partitions suits and twelve suits over eviction of squatters. From 1878 to 1882, the land was held in receivership. Sadly, Jose Loreto Sepulveda (who had sold or mortgaged his entire interest in the rancho) died in 1881, a broken man.

At the conclusion of these complicated lawsuits on September 25, 1882, the rancho was partitioned into seventeen portions. The largest share of 17,085 acres (about 53 percent of the 31,629-acre rancho), which included the Palos Verdes Peninsula, was awarded to Jotham Bixby, with only 12 remaining acres awarded to Juan Capistrano Sepulveda (who died in 1896) and about 4,399 acres (most of the town of San Pedro) awarded to the family of Jose Diego Sepulveda (A.W. Sepulveda), his younger brother.

Rancho Sausal Redondo, Rancho Ajuaje de la Centinela and Rancho Centinela

In its earliest days, El Segundo, Manhattan Beach and Hermosa Beach were part of the ten-mile ocean frontage of Rancho Sausal Redondo ("Round Clump of Willows"). In 1822, a year after Mexico had gained its independence from Spain, Antonio Ygnacio Avila was granted a permit to utilize grazing land totaling about 25,000 acres on what was to become Rancho Sausal Redondo, and on May 20, 1837, he received a land grant from Governor Juan Alverado for Rancho Sausal Redondo consisting of about 22,459 acres, which included the present-day cities of El Segundo, Gardena, Hawthorne, Hermosa Beach, Inglewood, Lawndale, Manhattan Beach and Playa del Rey. On June 19, 1856, the U.S. District Court issued a decree of confirmation of title to Antonio Ygnacio Avila for Rancho Sausal Redondo.

Where the city of Inglewood is today, there was another, smaller Mexican rancho called Rancho Ajuaje de la Centinela ("Sentinel of Waters"). This rancho was once part of Rancho Sausal Redondo, and Ygnacio Machado had encroached on the land claimed by Antonio Avila and was awarded provisional title to this land totaling about 2,200 acres at the same time that Antonio Avila received his land grant for the balance of the Rancho Sausal Redondo in 1837. In 1845, Machado traded the rancho to Bruno Avila, brother of Antonio Ygnacio Avila, for a small tract in the pueblo of Los Angeles. Bruno Avila, unfortunately, mortgaged his property at an interest rate of 6 percent per month, which was the standard interest rate at the time for personal loans; unable to repay his debts, he lost his property through foreclosure in 1857. Subsequent to this, the Rancho Ajuaje de la Centinela changed hands a number of times, eventually being acquired in 1860 for $3,000 by Sir Robert Burnett, a Scottish lord.

The Rancho Sausal Redondo property, consisting of about 22,459 acres, was purchased by Sir Robert Burnett on May 5, 1868, when it was sold to him through probate court for $30,000 to pay debts accrued by the Avila estate (Antonio Ygnacio Avila had died in 1858). Burnett combined the two ranchos under the name of Rancho La Centinela.

In 1873, Burnett leased the land to Catherine Freeman with an option to buy, and Burnett returned to his native Scotland. When Catherine died in 1874, her husband, Daniel Freeman, used the land for sheep, horses and orchards with fruit, almonds and olives. When a severe drought occurred

in 1875 and 1876, he incurred heavy losses. In 1882, Freeman used his option to buy 3,912 acres for the sum of $22,243. On May 4, 1885, Freeman purchased the remainder of Rancho La Centinela for $140,000. Daniel Freeman was the last person to own all of Rancho La Centinela. He eventually sold his land to several real estate developers.

Manhattan and Hermosa Beach History

Manhattan Beach History

In its earliest days, Manhattan Beach was part of the original Spanish land grant for Rancho Sausal Redondo in 1822, a rancho with a land mass of nearly twenty-five thousand acres, which extended from the areas as far north of what is now Playa del Rey, as far east as Inglewood and as far south as Hermosa Beach. At one time, the area was called Shore Acres by George Peck, who owned a section of the north end of town.

Developers were plentiful. Several of the larger developers—such as George Peck, who owned the northern section of the area, including north of Rosecrans; John Merrill, who was laying out the southern section, which was between First Street and Center Street and just west of the Santa Fe tracks to the Strand; and Frank Daugherty, who had twenty acres from Marine Avenue to Fifteenth Street and east of Highland Avenue to the railroad tracks—agreed that only one name should be given to the area. George Peck was calling his area Shore Acres after a Santa Fe junction sign. John Merrill called his development Manhattan Beach. According to Frank Daugherty, a half-dollar coin was flipped, and Manhattan Beach won. It is believed that this occurred in 1902 because the Santa Fe Railroad stop was named Manhattan Beach beginning in late 1903.

The first downtown building was built by Merrill in about 1901, a small frame building later used for city offices. Most of the early buildings were beach cottages. Families would come from Pasadena and Los Angeles on the trolley or Santa Fe train, and a real estate agent would greet them as they stepped off. Some liked what they saw and bought property. Manhattan Beach was promoted as a place to vacation, a summer resort. A few stayed year-round, but most stayed only for a weekend or a summer. It was hard to count the full-time residents, but by the time of incorporation on December 7, 1912, there were about six hundred permanent residents.

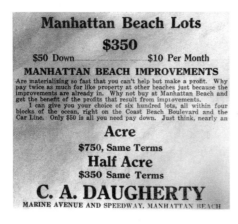

Ad for sale of lots in Manhattan Beach.
Courtesy Manhattan Beach Historical Society.

The original boundaries of Manhattan Beach included 3.31 square miles, and the annexation of an eastern tract in 1916 increased the total territory to 3.81 square miles. Because of its small area, population growth was slow. In 1920, it had 859 residents. In 1930, it had 1,891. And in 1940, it had 6,398. The 1930s saw the growth of the "tree section" and the "hill section."

After World War II, a large influx of people came as a result of the desirability of the area for year-round living. Servicemen visiting during the war returned to live here. The development of the defense industry brought many people to the South Bay to reside and work. Much of the land east of Sepulveda was developed to house the influx of people.

Manhattan Beach and Hermosa Beach Piers

Among the first structures built in Manhattan Beach were two wooden piers built in 1901, one at Center Street (later renamed Manhattan Beach Boulevard) and one at Marine Avenue called Peck's Pier and Pavilion.

The Center Street pier was believed to have been nine hundred feet long. Pilings were made by fastening three railroad rails together and driving them into the ocean floor. A narrow wooden deck was supported by these pilings. A wave machine was installed at the foot of the pier in order to generate electricity for the lighting system on the Strand, but the plan did not work. The "old iron pier," as it was called, was destroyed by a major storm in 1913.

Lack of money, lawsuits, storms and debates about when and where to build another pier delayed Manhattan Beach from having one completed until 1920. This time, it was a cement pier with a rounded end, and it was 928 feet long. Engineer A.L. Harris developed the concept of the circular end for less exposure and damage to the pilings by the waves. The roundhouse at the end was not completed until 1922. In 1928, the

pier was extended out 200 feet (at no cost to the city) when Captain Larsen of Redondo Beach offered to pay for an extension in exchange for the rights to run a shore boat between the pier and his barge *Georgina*. On January 9, 1940, 90 feet of the extension were ripped away during a winter storm. The extension was never repaired, and the remaining section was swept away in February 1941. In 1946, the pier and adjoining beach were deeded over from the City of Manhattan Beach to the state.

Storms and time were not kind to the pier, and repairs were made; however, the appearance changed. In 1991, a decision to restore it back to its 1920s appearance was made. The roundhouse was completely rebuilt and is now occupied by the Roundhouse Marine Studies Lab & Aquarium. In 1995, the pier was declared a state historic landmark. It is the oldest standing cement pier on the West Coast.

In 1904, the first Hermosa Beach pier was built. It was constructed entirely of wood, even to the pilings. It extended five hundred feet out into the ocean, but it was destroyed in a storm in 1913. One year later, Hermosa completed its second pier, a one-thousand-foot concrete structure complete with small, tiled pavilions along the sides to afford shade for fishermen and picnic parties. Eventually, a bait stand was built out on the end.

General Rosecrans

General William Starke Rosecrans (or "Old Rosy," as he was known to his men) was born in Kingston Township, Ohio, on September 6, 1819. The original family name was "Rosenkranz," which means "crown" or "wreath of roses."

He attended West Point and, upon his graduation, joined the U.S. Army Corps of Engineers. He resigned his commission in 1854 after reaching the rank of first lieutenant in order to spend more time with his family. With the outbreak of the Civil War, Rosecrans reenlisted in the army and became a brigadier general. He was considered one of the Union's brightest leaders until his forces were defeated at Chickamauga in September 1863. After that battle, Secretary of War Edwin Stanton and General Ulysses S. Grant relieved him of command, an action that embittered Rosecrans against the two men.

In 1864, some historical sources note, Rosecrans was offered the vice presidency by Abraham Lincoln, but his acceptance cable to Washington,

D.C., never got through. Speculation ran that Secretary of War Stanton intercepted and destroyed it.

After a stint as U.S. ambassador to Mexico from 1868 to 1869, Rosecrans settled in San Francisco, where he became one of the eleven founders of the Southern Pacific Railroad. He eventually migrated south to Los Angeles. In 1869, he purchased thirteen thousand acres of the Rancho Sausal Redondo land grant for $2.50 per acre.

His property, which would become known as Rosecrans before eventually becoming part of Gardena and South Los Angeles, was bordered by, roughly, Crenshaw Boulevard on the west, Central Avenue on the east and Florence Avenue on the north, with a southern border just north of Artesia Boulevard. He built a family home near the present-day intersection of Vermont and Rosecrans Avenues, where he became a gentleman farmer.

After many entreaties from his supporters over the years to run for public office, he served in the House of Representatives until 1885. In 1885, he was appointed registrar of the U.S. Treasury, the person whose signature at that time appeared on U.S. currency along with that of the secretary of the treasury.

In 1887, he returned to his Southern California home and began developing his land as the town of Rosecrans. He subdivided his land into three thousand house-size lots, which he began selling for fifty dollars each.

Rosecrans resigned as registrar of the treasury in June 1893. Around this time, Rosecrans, then in his mid-seventies, moved into the luxurious Hotel Redondo and became a well-known figure in Redondo Beach. When his health began to fail, he was moved back to his house in Rosecrans, where he died on the morning of March 11, 1898.

In addition to Rosecrans Avenue, the general has been commemorated by the Fort Rosecrans military post at Point Loma in San Diego, Rosecrans Hall at Loyola Marymount University in Westchester, Gardena's General William Starke Rosecrans Veterans of Foreign Wars Post No. 3261, Rosecrans Park in Gardena and Rosecrans Elementary School in Compton.

History of the Strand

Manhattan Beach is built on sand. Planks were laid in the sand on Manhattan Avenue for vehicles and along the Strand and side streets for pedestrians. Old-timers speak of walkways in the early days disappearing, small structures sliding and the sting of the sand. The dunes were a major

problem. Some were fifty to seventy feet high. In a story told by Marshall Kuhn, a local businessman, to a newspaper reporter sometime in 1973, he noted that in the late 1920s, developers from Hawaii made a deal with the Kuhn Brothers Construction Company to supply Waikiki Beach with Manhattan Beach sand. The sand was loaded onto the Santa Fe Railroad cars and transported to the harbor in San Pedro and then onto ships or barges. This continued for almost ten years. This story has never been able to be verified by the local historical society, however.

A steady wind whipping across the barren dunes made life miserable for the first hardy pioneers. One of them, Mrs. Dorcas Ingram, set down her views for posterity, relating in part, "But my inmost being shrank from the greeting chill and dank of a wind forever blowing o'er the sand dunes of Hermosa."

Many of the early settlers collected their own narrow planks and built precarious walkways between frequented spots. The hardier ones didn't bother—they plodded through the sand. The first official survey was made

The corner of the Strand and Center Street (later renamed Manhattan Beach Boulevard) in Manhattan Beach, circa 1915. *Courtesy Manhattan Beach Historical Society.*

The PE trolley tracks, boardwalk, beach cottages and the old iron pier, circa 1913. *Courtesy Manhattan Beach Historical Society.*

in 1901 for the boardwalk on the Strand in Hermosa Beach. A short time afterward, a record 500,000 feet of Oregon pine was installed along a mile and a half of the Strand. This was duly recorded as a notable achievement by loyal Hermosans but drew sneers from nearby Redondo residents, who called it "a walk to the middle of nowhere." High tides sometimes washed away portions of this walkway. In 1914, part of it was replaced with cement. The remaining two thousand feet on the north were completed in cement in 1926.

During the early 1900s in Manhattan Beach, planks were also placed on the sand to create Manhattan Avenue, and boardwalks were built along the Strand and on side streets.

In 1903, the Pacific Railway Company, which merged with the Pacific Electric in 1910, installed a track along the oceanfront extending from Los Angeles to Santa Monica and then south to Redondo Beach, passing through Manhattan. The tracks were just west of the Strand, where the bicycle path is today. The Red Cars would run on this line until 1940.

Today, the Strand through Manhattan Beach and Hermosa Beach is home to some of the most desirable homes in the world.

Hermosa Beach History

Hermosa Beach was part of the original Spanish land grant for Rancho Sausal Redondo in 1822, a rancho with a land mass of nearly twenty-five thousand acres that extended from the areas as far north of what is now Playa del Rey, as far east as Inglewood and as far south as Hermosa Beach.

In the early days, Hermosa Beach, like so many of its neighboring cities—such as Torrance, Lawndale and Inglewood—was one vast sweep of rolling hills covered with fields of grain (mostly barley). The immediate beach area of Hermosa was a collection of sparse-looking sand dunes seemingly forty miles from nowhere. A steady wind whipping across the barren dunes made life miserable for the first hardy pioneers.

On Christmas Eve 1906, Hermosa Beach held its first incorporation election and chose its first city officers. In the interest of accuracy, it's only fair to report that the idea of incorporating the city didn't get a resounding vote of confidence from an eager mob of voters. The final tally was twenty-four votes for and twenty-three against. But resounding or not, Hermosa Beach was duly incorporated and received its charter from the state as a sixth-class city on January 14, 1907.

The Santa Fe Railroad was the only transportation system that ran through Hermosa Beach. It was seven blocks from the beach. The street that led to the tracks was called Santa Fe Avenue but was later renamed Pier Avenue. There was no railway station for Hermosa, but later the railroad company donated an old boxcar to be used as a storage place for freight. In 1926, the Santa Fe Company built a modern stucco depot and installed Western Union telegraph service in it.

One of the most ambitious projects attempted in the city came in the mid-1920s with the opening of the building that later became the Hermosa Biltmore Hotel. The hotel was located between Fourteenth and Fifteenth Streets on the Strand. In those days, it was the headquarters for the Surf and Sand Club and was run on a private club basis. A number of wealthy persons backed the project, and for several years, the building (a notable achievement in those days) was the showplace and social center of Hermosa. The private club idea proved to be a losing proposition, however, and a few years later, the founders and owners sold out to the Los Angeles Athletic Club. This group, with better financing, attempted to run the property on more or less the same basis but finally sold out to hotel interests in about 1930. During World War II, for a short time, the building was taken over by the federal government and used as a

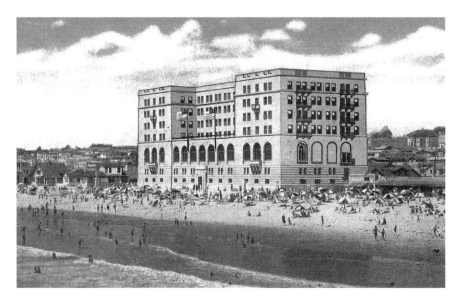

A 1931 Hermosa Beach Biltmore Hotel postcard. *Courtesy Marilyn Ron collection.*

youth training center. This property was torn down in the late 1960s for development and is now the site of a public park.

Hermosa Beach was also home to a small oceanarium in the 1950s. The large blue building, which opened in 1947, was round in shape, so visitors could walk in a circle along the building's edges. The building was located just south of the Hermosa Beach Pier on the Strand. The underwater zoo clocked about 1.8 million visitors, including more than 25,000 group tours from the Boy Scouts and other youth and school organizations. The oceanarium closed in 1956, and the city bought the land for a parking lot in 1958.

San Pedro History

San Pedro: Early Port History

By 1835, San Pedro had become the most important port on the Pacific Coast. Because of shallow water and mud flats, ships had to drop anchor about one mile offshore, and small boats would then transfer passengers

and cargo ashore. These would often capsize, spilling both passengers and cargo into the muddy water. During this time, the Sepulveda family built a crude dock and landing at the base of cliffs near present-day Fourteenth and Beacon Streets in San Pedro; this became known as Sepulveda Landing.

Two major geographical features of San Pedro Harbor at this time were Deadman's Island (which was later dredged and became part of the current breakwater) and Rattlesnake Island (which later became Terminal Island). Rattlesnake Island was known as such because it was home to a large population of rattlesnakes, which migrated down the Los Angeles River. The name was changed to Terminal Island by the railroad company because of the terminus of the rail line established there.

In 1851, twenty-one-year-old Phineas Banning arrived in San Pedro from Philadelphia. Banning and his partner, George Alexander, soon began operating a stagecoach service from San Pedro. When August Timms bought the Sepulveda Landing, early in 1852, Banning was concerned (Sepulveda Landing then became known as "Timms' Landing").

When word came from Washington that San Pedro would soon be declared an official port of entry with its own customhouse, Banning negotiated to buy a tract of land from the Sepulvedas, located near Timms' Landing, and promptly built his own wharf. In November 1854, Banning and a group of investors (J.G Downey, Don Benito Wilson and William Sanford) purchased 2,400 acres adjacent to San Pedro for port expansion. This land later became the city of Wilmington, after Banning's Delaware birthplace.

In the late 1860s, Banning realized that for San Pedro Harbor to become a center of commerce, three things needed to be accomplished: building a railroad, constructing a breakwater and dredging the harbor to accommodate large ships and to allow them to dock directly at the wharfs. In October 1869, construction was completed on the Los Angeles and San Pedro Railroad, Southern California's first railroad. On March 2, 1871, Congress voted an appropriation for construction of a rock jetty from the lower end of Rattlesnake Island to Deadman's Island.

In 1872, the Southern Pacific Railroad agreed to run its railroad through Los Angeles and purchased the Los Angeles and San Pedro Railroad. In 1881, it built an extension of the Los Angeles and San Pedro Railroad across the Wilmington Lagoon on pilings to a point near Timms' Point, thus enabling direct railroad access to the deep-water wharf. Phineas Banning died in 1882, but his dream of making San Pedro a major port of entry to the United States would soon be realized.

The Battle to Build San Pedro Harbor

Two new railroads competed to build the dominant port for the Los Angeles area. The Santa Fe Railroad constructed a wharf in Redondo Beach that shipped a considerable amount of lumber from there. On April 13, 1892, the Dominguez heirs sold Rattlesnake Island in San Pedro to a competing railroad, the Los Angeles and Terminal Island Railroad Company.

In 1891, a survey was commissioned as to a recommendation for the location for continued funding and construction of a deep-water port for Southern California. This survey had recommended San Pedro as the desired location for the port. Collis P. Huntington, who now headed up the Southern Pacific Railroad, had become annoyed by the competition of the Los Angeles and Terminal Island Railroad, as well as the Santa Fe Railroad in Redondo Beach. Thus began a vigorous lobbying campaign to designate Santa Monica Bay for harbor development, since the Southern Pacific Railroad completely controlled this option. By 1893, Southern Pacific's railroad extension and wharf in Santa Monica were in full operation.

In 1896, an appropriations bill was approved by a congressional committee to fund the construction of a breakwater in Santa Monica, but an amendment was passed to the bill calling for a new commission to be appointed to review the best location for a deep-water port. *Los Angeles Times* publisher Harrison Gray Otis and U.S. senator Stephen White pushed for federal support of the Port of Los Angeles at San Pedro Bay. The matter was settled when San Pedro was endorsed in 1897 by a commission headed by Rear Admiral John C. Walker. Finally, in 1898, San Pedro was selected for the port improvements appropriation, and construction began on the new federal breakwater project in San Pedro. This intense congressional battle was dubbed the "Battle for a Free Port" because it was feared that given the Southern Pacific's monopoly of the Santa Monica port, there would be no competition at the new port.

Construction of the breakwater began in 1899, with the first section completed in 1912. In 1906, the City of Los Angeles purchased a long, narrow strip of land, half a mile wide, from Slauson Avenue, connecting the city to the cities of San Pedro and Wilmington (now known as the "Harbor Gateway" community). In 1909, the city annexed San Pedro and the adjacent town of Wilmington. The odd shape is still seen in the map of the city.

In 1888, the U.S. War Department took control of a tract of land next to the bay and added to it in 1897 and 1910. This became Fort MacArthur in 1914 and was a coastal defense site for many years, which also included

a Nike missile site in the White Point area. In 1978, the secretary of the interior transferred ownership of the White Point U.S. Naval Reservation to the City of Los Angeles to be used for recreational purposes.

San Pedro White Point Resort

Between the turn of the twentieth century and World War II, the White Point area of San Pedro was home to a thriving Japanese community of abalone fisherman and farmers. In 1899, twelve Japanese fisherman leased beachfront property at White Point from Ramon Sepulveda, a descendant of Jose Dolores Sepulveda, the original Spanish land grant owner of San Pedro, with the intention of establishing an abalone and lobster fishery at that location. By 1903, they had earned enough money to construct a cannery at the fishery. This profitable industry ended in 1908 when it was alleged that these settlers were using fishing as a front for spying on coastline activities. Laws restricting how much shellfish could be taken were also enacted when the lobster and abalone population was quickly depleted.

After the fishery closed, the area became a Japanese farming community and a resort locale. In 1915, Tojuro and Tamiji Tagami, with the help of Ramon Sepulveda, developed the area as the White Point Health Resort, a seaside resort centered on a sulfur spring at the base of the cliffs. Tamiji suffered severely from arthritis, but after several weeks of immersion in the hot water from the ocean, he recovered and was again able to work. So they built a bathhouse and then constructed the balance of the resort, which consisted of a two-story, fifty-room hotel and restaurant, with a dance floor, three saltwater plunges, an enclosed boating area, a bathhouse and a pier that ferried tourists to a nearby fishing barge. Local children often bathed in the sulfur water on their way home from school. Doctors would send patients to the resort for the therapeutic powers of the hot springs, and tourists would stay there for the beauty of the weather and location.

Various disasters in 1928 and the late '30s led to the decline and eventual closure of the property when storms damaged the pools and some of the buildings. In 1933, an earthquake sealed off the sulfur springs. Although the Tagamis continued to operate the hotel, they never actually owned the land. Ramon Sepulveda could not legally sell the land to Asian immigrants under a California law that prohibited ownership of land by those not

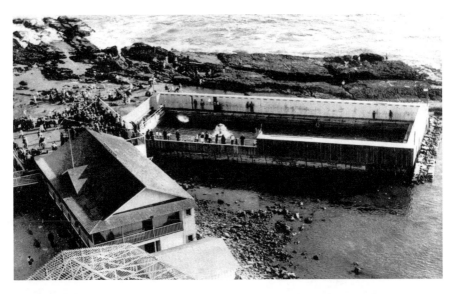

A 1922 aerial view of a celebration at White Point. *Courtesy Palos Verdes Library District Local History Collection.*

eligible to become citizens. Although the hotel continued to operate despite these setbacks, the final double blow came in the late 1930s with the rise of anti-Japanese prejudice and depressed economic conditions that combined to force the closure of the resort.

After the start of World War II, the federal government took over the area. It became part of the nearby Fort MacArthur military complex. The resort's buildings were demolished, and fortifications were added to the shoreline and nearby hillside. Two sixteen-inch guns were installed to fortify the two fourteen-inch guns at Fort MacArthur.

The State of California bought the beach area in 1960, and it became Royal Palms State Beach. In 1995, the land was acquired by the County of Los Angeles and became Royal Palms County Beach.

San Pedro's Drum Barracks: The Great Camel Experiment

The military has had a long history in San Pedro. Camp Drum was established as a five-company Civil War outpost originally named Camp San Pedro in January 1862, on land donated by Phineas Banning and Benjamin D. "Don Benito" Wilson. This post was later designated as

Camel at Drum Barracks. Courtesy *Los Angeles Public Library Photo Collection.*

Drum Barracks. It was named by the U.S. War Department in honor of Lieutenant Colonel Richard Drum, assistant adjutant general of the Department of California.

Drum Barracks became a footnote in U.S. military history when it participated in the grand experiment of utilizing camels in troop movements. Thirty-one camels were originally stationed at Fort Tejon,

which guarded Tejon Pass in North Los Angeles County. When the First U.S. Dragoons abandoned the fort to act as a deterrent against possible secession in downtown Los Angeles, the camels accompanied them. At first, they gathered crowds, but the novelty of the creatures soon wore out. Residents of Los Angeles began complaining of the smell, asking the military to move them elsewhere. They came to Camp Drum in early 1862.

In 1863, Major Clarence E. Bennett, post commander, complained as well. He blamed failure of previous camel use on government employees who "regard service with camels as being extremely unpleasant." He said, "In appearance camels are extremely ugly, in gait very rough, in herding inclined to wander, and with their long strides they make haste slowly, keeping their herders on the go." He recommended the camels at Drum be tested for service across the Mojave Desert and be shipped to Fort Mojave because almost all the grass at Drum was gone. The idea was not approved, the camel experiment was then deemed unsuccessful and the camels were auctioned off at Benicia Depot the next year.

In late 1870, the camp was officially abandoned. Wilson donated ten acres of land and two buildings at the Drum Barracks to the Methodist Church after the government returned the land to him and Phineas Banning in 1873.

The church took Wilson up on his plan, establishing Wilson College in the two buildings, the former hospital and the senior officers' quarters building. The first class term ended in July 1874, with the first full academic year starting in August 1874. Unfortunately, a financial panic in 1875 devastated the college, forcing it to close. The Methodist Church had more prolonged success with a 348-acre land grant that it received from J.W. Hellman, J.G. Downey and O.W. Childs that was located a few miles north of Wilson College. The church built a college there that opened on October 6, 1880, and eventually developed into the University of Southern California.

Wilson College is still considered to be the first coeducational college to be established west of the Mississippi River. The site now houses the Drum Barracks Civil War Museum, located at 1052 North Banning Boulevard in Wilmington.

San Pedro Landmarks

VINCENT THOMAS BRIDGE/TERMINAL ISLAND FERRY—The Vincent Thomas Bridge is a 1,500-foot-long suspension bridge crossing the Los Angeles Harbor linking San Pedro, California, with Terminal Island. Prior to the bridge's construction in 1963, the Terminal Island Ferry transported people and cars to Terminal Island. The ferry building was a working ferry terminal from 1941 to 1963 and currently houses the Los Angeles Maritime Museum. The bridge is named after California assemblyman Vincent Thomas of San Pedro.

FORT MACARTHUR—In 1888, the War Department took control of a tract of land next to the San Pedro Bay and added to it in 1897 and 1910. This became Fort MacArthur in 1914. It was a coastal defense site for many years and also included a Nike missile site in the White Point area. The

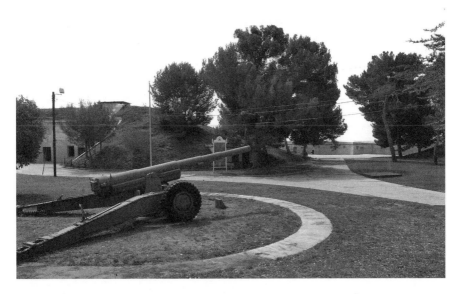

Entrance to Fort MacArthur. *Photo by Bruce Megowan.*

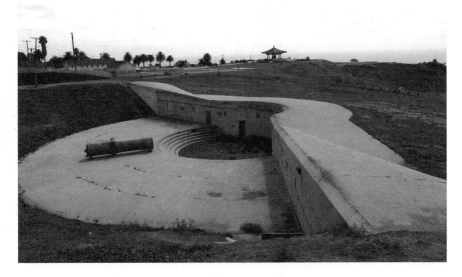

One of two fourteen-inch gun emplacements at Fort MacArthur. These were installed for World War I and were also used during World War II. Note the Korean Bell in background at Angels Park. *Photo by Bruce Megowan.*

gun emplacement here included two fourteen-inch guns during World War I. Two sixteen-inch guns were added to the White's Point area below the fort for World War II. In 1978, the secretary of the interior transferred ownership of the White Point U.S. Naval Reservation to the City of Los Angeles to be used for recreational purposes. The entrance to the Fort MacArthur Museum is at Gaffey and 32nd Street (follow the blue line in the road).

KOREAN BELL—The Korean Bell of Friendship is a massive bronze bell housed in a stone pavilion in Angel's Gate Park, in the San Pedro district of Los Angeles, California. It is located at the corner of Gaffey and 37th Streets.

The bell was donated by the Republic of Korea to the people of Los Angeles, California, to celebrate the bicentennial of the United States, to honor American veterans of the Korean War and to symbolize friendship between the two nations. It was dedicated on October 3, 1976.

This page and next: Korean Bell at Angels Park. *Photo by Bruce Megowan.*

POINT FERMIN LIGHTHOUSE—Built in 1874 in Stick/Victorian style, the Point Fermin Lighthouse was the first navigational light in the San Pedro Bay. Phineas Banning proposed construction of the lighthouse in 1854; however, land disputes delayed its construction until 1874. On December 7, 1941, Pearl Harbor was bombed, and the coast was blacked out for fear of being a beacon to enemy ships and planes—that included turning off the lighthouse beacon. Sadly, the light was never to be lit again. The lighthouse is located in Point Fermin Park at the end of Gaffey Street.

THE MULLER HOUSE—Steeped in history, the Muller House was originally located at 129 Front Street in the Nob Hill neighborhood of San Pedro California and moved to 1542 South Beacon Street, San Pedro, when Front Street was widened. The Colonial Revival–style house was built for the parents of Edward "Big Ed" James Mahar, mayor of San Pedro. In 1901, shipbuilder William Muller bought the home for his family.

The house was owned by the Mullers from 1906 to 1963, when they donated it to the San Pedro Bay Historical Society. The society restored it and now operates it as a museum. The Muller House is now situated on a knoll at the south end of Beacon Street.

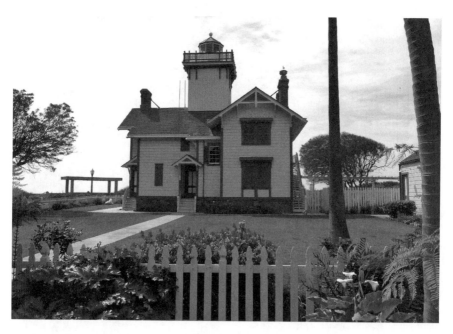

Point Fermin Lighthouse. *Photo by Bruce Megowan.*

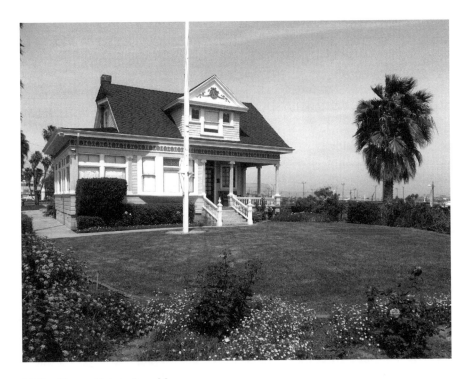

Muller House. *Photo by Bruce Megowan.*

History of El Segundo

Prior to El Segundo's incorporation in 1917, this area was part of the original Spanish land grant for Rancho Sausal Redondo in 1822. The land consisted of wheat and barley fields on which cattle and sheep grazed.

In May 1911, five men representing the Standard Oil Company arrived here: Richard J. Hanna and J.E. Howell of the Eclipse refinery of Franklin, Pennsylvania; and John Black, Henry Foster and William Rheem from the Standard Oil refinery in Point Richmond, a city eighteen miles east of San Francisco. They were surveying the area as a potential site for their next oil refinery. What was required was an area adjacent to the seashore so their tankers could have appropriate access. The undeveloped nature of the site appealed to them because land costs had to be kept to a minimum. Also, the site had to be close to populated areas so it could attract enough employees. The rancho area was just what Mr. Hanna's team was looking for.

Lastly, this new site needed a name. Richard Hanna's wife, Virginia, deemed this expanse as "El Segundo" (Spanish for "the second one") because the site was to be Standard Oil's second oil refinery in California (the Point Richmond refinery was already christened as "El Primero"). Sometime later, a group of proud but unknown citizens nicknamed it "El Segundo a nada" ("second to none").

Standard Oil bought 840 acres of this land on June 11. The refinery opened for business just five and a half months later on November 27, 1911, and just recently celebrated its 100th anniversary of operations.

The city remained a one-industry town until the 1920s, when Mine's Field, a landing strip used by early barnstormers, was chosen as the site for the new Los Angeles Municipal Airport. Then, in the mid-1950s, Southern California Edison purchased a forty-three-acre site for a major electrical generating station.

Naturally, the addition of the Los Angeles International Airport, which officially opened in 1930, had a major role in turning El Segundo into an aerospace center. The likes of Douglas Aircraft, Hughes Aircraft, Northrop and North American Aviation (Rockwell) all located in El Segundo during the 1940s and 1950s. Most of these aircraft-related companies would eventually transition into the aerospace/defense industry. In 1960, the creation of the Aerospace Corporation and Los Angeles Air Force Base gave El Segundo the esteemed title of the "Aerospace Capital of the World."

Today, the city encompasses more than five square miles, and the city's population has leveled off at about 16,500 residents; this has enabled the community to preserve the small-town intimacy and charm.

History of Torrance

Torrance was founded on May 31, 1911, by Jared Sidney Torrance and Associates through the purchase of 2,791 acres of land from the Dominguez Estate Company for $976,850. Susana Dominguez del Amo sold an additional 730 acres to Torrance for $350 per acre. This land was originally a small part of the Spanish land grant called Rancho San Pedro, given to Juan Jose Dominguez in 1784. At its inception, this planned industrial town provided housing for five hundred people.

In March 1912, Torrance had originally proposed that the new development be named Dominquez. The post office would not allow this

since there was already a post office with that name. On March 12, 1912, at a meeting of the board of directors of the Dominquez Land Company, of which Jared Torrance was president, this issue was discussed, with many variants of the name "Dominquez" considered. Other names considered included Southport, Coronel, Obrador, Don Manuel and Industrial. Finally, over the objections of Jared Torrance, the board approved a resolution naming the new development "Torrance."

Frederick Law Olmsted Jr. of Boston, the foremost landscape architect of the country at the time who provided the landscape planning for the Palos Verdes Project, laid out the new industrial community of Torrance. On the broad, empty cornfield, he placed the industrial sites in the lee of the town, away from the prevailing westerly breeze; chose a knoll for the civic center; designated the sites of the city hall, library, auditorium and other public buildings; backed his civic center with a thirty-acre park; and, fixing his eyes firmly on the white peak of Mount San Antonio at the horizon, laid out a broad boulevard straight through the business center toward the snowy crest. In addition, he gave individual homesites a minimum width of 40 feet and a depth of 140 feet, which was much larger than most homesites on the East Coast.

The Pacific Electric Railway depot in Torrance, at 1250 Cabrillo Avenue, was completed in 1912 to serve Red Car passengers on this Torrance spur from the Gardena Line. The depot is now a popular restaurant.

The discovery of oil brought the initial development of Torrance. At the time the city was incorporated in May 1921, it had 3.82 square miles and a population of about 1,800 residents. The first oil well was dug in December 1921, and it was a gusher. The discovery of oil had increased the population to 2,750 by 1922. Soon, there were oil derricks throughout the city. From 1926 to 1931, five annexations of land took place, increasing Torrance to 18.88 square miles. Today, Torrance consists of about 21.00 square miles.

By the early 1950s, there were 615 oil wells. In the late 1950s, however, oil production decreased significantly. Finally, an edict was passed by the city requiring the removal of all wooden oil derricks by July 1, 1961. The final tower came down in 1963. Torrance has now become one of the largest cities in Los Angeles County today.

Hollywood Riviera

Hollywood Riviera is an area located in both Redondo Beach and Torrance at the base of the Palos Verdes Peninsula. The Hollywood Riviera was initially developed by Clifford Reid, who was fascinated by the motion picture industry. When he first viewed the area, Rein compared it to the French Riviera. He believed that it would be very attractive to the Hollywood crowd, thus naming it Hollywood Riviera.

A tract sales office was built at the corner of Monte D'Oro and Palos Verdes Boulevard that included a large dining hall and lecture hall built behind the office for sales presentations. Reid began selling lots in the 604-acre development in 1927 for the Huntington Land Company for about $3,500.

Reid's plan to attract movie stars to buy lots was severely affected by the Depression, as well as the development's anti-Semitic policies, which prohibited Hollywood elites such as Louis B. Mayer and Sam Goldwyn from owning property there.

Clifford Reid built the Hollywood Riviera Beach Club in 1931 as a glamorous amenity that would encourage homebuyers to buy lots. Residents of the Hollywood Riviera development automatically became members of the club, although dues were required to use the pool and attend special events held there. The club was located on the beach at the current location of Miramar Park and had a seventy-five-foot swimming pool. A miniature golf course existed just east of the Beach Club in the early '30s where the Vista Bahia apartments now stand.

Roy Stewart, Reid's brother-in-law, managed the club from 1930 to 1942. Several South Bay organizations met at the club. Not long after Pearl Harbor, the military installed antiaircraft guns in the hills by Torrance Beach, and the pounding of the ensuing target practice structurally damaged the club, which closed in 1942.

The club reopened after the war (after Reid sold it), and its new owners made it a public club that operated throughout the 1950s as a night club. The border of Torrance and Redondo Beach ran down the middle of the club, and supposedly customers would have to cross from one side of the tavern to the other to stay in compliance with each city's liquor laws.

Unfortunately, the club suffered some flood damage from storms both in 1955 and 1957. Norton Wisdom had taken over the club in 1957 and signed a new lease that extended until June 30, 1965. Mysteriously, on September 25, 1958, a fire broke out that completely destroyed the club.

For years afterward, plans were made to redevelop the site. One proposal was a teen center. In 1964, the Sovereign Development Company proposed a plan to build a sixteen-story apartment complex on the site, but the proposal was opposed by Hollywood Riviera residents. Eventually, in 1972, courts ruled that the property's then-owner, Oscar Berk, could not build on the property that he had purchased for $600,000 as the land had reverted to public ownership.

Redondo Beach History

Redondo Beach

In 1854, a natural salt lake (known as the "Old Salt Lake") located between Pacific and Francesca Avenues at the northern end of Redondo Beach, just outside Hermosa Beach, was sold to Henry Allenson and William Johnson. This sale precipitated the establishment of Pacific Salt Works, which extracted and sold salt and operated through circa 1908.

When Don Miguel Dominquez died in 1882, he left the Rancho San Pedro to his six daughters. Three of his daughters—Susana, Guadalupe and Maria de Los Reyes Dominguez—inherited portions of the estate, each including individual sections collectively known as the Ocean Tract. In 1890, Susana Dominquez married Gregorio Del Amo y Gonzalez. Del Amo Boulevard is named after this family.

In 1889, this coastal tract of 433 acres was sold to the Redondo Beach Improvement Company, founded by Robert Thompson and John Ainsworth, for $12,000. They promoted, developed and sold land that eventually became the nucleus of the city of Redondo Beach. On April 18, 1892, Redondo voters adopted cityhood by a vote of 177 to 10. The first city hall was built in 1908 at Benita Street and Emerald Street.

The name of the city is Spanish for "round," which either refers to the half-round street pattern of the original town site or the adjacent Rancho Sausal Redondo, which was just north of the city.

The city was becoming "the place" for tourists. Railroads and steamships brought people by the thousands, not to mention freight loads of oil and lumber. At this time, Redondo was the first port of Los Angeles County. Steamers from the Pacific Steamship Company stopped at Redondo four times per week at one of its three piers, as part

of regular runs between San Francisco and San Diego. The Redondo Railway Company and the Santa Fe Railroad left Los Angeles daily for Redondo at regular intervals. Eventually, the city was served by Henry Huntington's Big Red Electric Cars.

Redondo's popularity began a slow decline when San Pedro Harbor started to take shape in 1899. By 1912, the Pacific Steamship Company had stopped calling at Redondo altogether. Lumber schooners still used Pier No. 3 at Topaz Street until the railroad pulled out in 1926. Because of prohibition, the $250,000 Hotel Redondo closed its doors and in 1925 was sold for scrap lumber—the price was $300.

Storms have been an ever-present danger to the city's piers. They have been washed out and then rebuilt, only to be washed out again. Redondo's first breakwater was built in 1939, and although the cost was more than $500,000, it provided only limited protection. Because of the way it was constructed, wave action and the normal movement of the beach sand was altered. Following every storm, sand accumulated north of the breakwater. Eventually, the beach area between Diamond and Beryl Streets was obliterated. A raging storm in 1953 caused extensive damage not only to the breakwater but also to city streets and private property.

Redondo's population boomed in the 1950s and 1960s. In 1890, the population was 668; in 1940, it was 13,092; and in 1965, it was 54,772. Today, Redondo citizens number a little over 63,000.

Early Redondo Beach

Redondo Beach was the home of California's first modern surfer. In 1907, Henry Huntington brought the ancient art of Hawaiian surfing to the California coast. He owned most of the properties in Redondo Beach and was eager to sell them to visiting Angelenos looking for a break from the heat of the Greater Los Angeles basin. Huntington had seen Hawaiian beach boys surfing and decided to hire one of them—a young Hawaiian-English athlete named George Freeth—to demonstrate the art of surfing for the entertainment of Redondo Beach visitors.

George wanted to revive the art of surfing that he had seen depicted in old Polynesian paintings but found it difficult and had little success using the typical sixteen-foot hardwood boards. He cut them in half and unwittingly created the original long board, which worked exceedingly well and made him the talk of the Hawaiian Islands.

George Freeth. *Courtesy Redondo Beach Historical Society.*

Starting in 1908, the "Man Who Could Walk on Water," as he was called, gave surfing demonstrations for the many tourists arriving at the beach on the big red streetcars. George exhibited his surfing prowess for Redondo Beach visitors twice a day in front of the Hotel Redondo. He was eventually made the official Redondo Beach lifeguard and the first lifeguard in Southern California. From 1907 to 1915, George spread a surfing revolution that would eventually become a phenomenon on the California coast. A memorial bronze statue of George Freeth was placed at the Redondo Beach Pier, and it is often decorated with leis as tribute from surfers who visit from around the world.

Several natural and man-made novelties lured early visitors to Redondo Beach. Between Diamond Street and the Hermosa Beach city line, there was Moonstone Beach. Natural mounds five to six feet deep and forty to fifty feet wide of gemstones were there for the taking.

Carnation Gardens, in the general vicinity of Ruby and Sapphire Streets east of Catalina Avenue, offered twelve acres of sweet-smelling flowers that were almost always in bloom. The piers, too, were an attraction. Sport fishing was unsurpassed, and amusements such as games, rides and the largest saltwater plunge in the world added to the excitement.

One of the more interesting parks in Redondo Beach is Wilderness Park, an eleven-acre oasis that feels like you are way out in the country. This park was originally a Nike missile site that was decommissioned by the federal government and transferred to the City of Redondo Beach on May 7, 1971. This park is available for overnight campouts.

Another attraction is the Seaside Lagoon, a saltwater swimming area constructed in the early 1950s that is heated by the hot water used by a nearby utility plant to generate steam for the generation of electricity. Besides swimming, the lagoon offers a large sand area for sunbathing, children's play equipment, snack bar facilities and volleyball courts. There is also a grassed area and luau shelter for day and evening events.

The Redondo Beach Pier

There have been seven piers constructed on the Redondo Beach shoreline over the years. Between 1889 and 1903, three piers were constructed to service freight activity when Redondo Beach was competing against the San Pedro Harbor for dominance. Wharf 1 was constructed at Emerald Street in 1889, Wharf 2 was built in 1895 just south in front of the Hotel Redondo and Wharf 3 was built south of Wharf 2 near Sapphire and Topaz Streets in 1903. The Santa Fe Railroad provided rail service to the piers. Violent storms in 1915 and 1919 destroyed Wharfs 1 and 2, and diminishing freight deliveries led to the removal of Wharf 3 in 1926.

In 1916, a municipal pier referred to as the "endless pier" was constructed in a "V" shape to replace the destroyed Wharf 1. A 450-foot-long northern leg began at the former location of the old Wharf 1. At the western end of the northerly leg stood a 160- by 200-foot platform. From this platform, the pier headed back to shore just south of the bathhouse on the 450-foot southern leg. In November 1925, Captain Hans C. Monstad constructed a pier adjacent to the endless pier to provide landings for all fishing boats and pleasure craft operating in Redondo Beach, including the gambling ship *Rex*. By 1938, the pier had been extended to 450 feet.

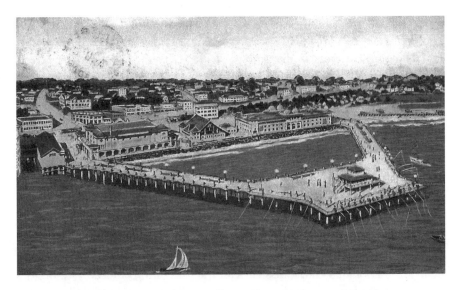

Postcard of Pleasure Pier, constructed in 1916. *Courtesy Marilyn Ron Collection.*

The 1919 storm that destroyed Wharf 2 severely damaged the endless pier; ultimately the pier was demolished in 1928, and a new wooden horseshoe-shaped pier was constructed in 1929. By connecting the west end of the Monstad Pier with the center of the Horseshoe Pier in 1983, the Fishing Promenade provided more space for sport fishing.

January 1988 storms battered the pier and destroyed the Fishing Promenade. In May 1988, fire destroyed most of the Horseshoe Pier. After many years of public debate about the future of the pier, the reconstructed concrete Redondo Pier opened in 1995. Architect Edward Beall designed shade structures that symbolize the sails and masts of the old sailing ships that visited Redondo. The new pier connected the 1925 Monstad Pier, the remainder of the 1929 pier and the location of the 1889 Wharf 1.

In 2012, the Redondo Landing building at the entrance to the pier was renovated. The city has recently acquired the Pier Plaza and International Boardwalk leaseholds in King Harbor and now owns a fifteen-acre stretch of property from Torrance Boulevard to Portofino Way. In January 2013, the city entered into an exclusive negotiating agreement with El Segundo's CenterCal Properties to redevelop the fifteen acres of city-owned land on the Redondo Beach waterfront, including the Redondo Beach Pier. The project is expected to take several years and cost between $150 and 200 million. The city and the developer are continuing to hold public meetings to receive public input as to the future design. Groundbreaking is not expected to occur until at least 2015.

Redondo Beach Landmarks Forever Gone

HOTEL REDONDO—In 1890, the Hotel Redondo opened overlooking the ocean near the present-day pier to serve the thousands of visitors coming by steamship and several railway lines. With its eighteen-hole golf course, lush landscaping, tennis courts and 225 luxurious rooms, the hotel induced more visitors than ever before to venture to the coast. If the price of hotel accommodations was too steep, one could rent a tent at nearby Tent City on property just north of the hotel. Patrons were charged $3 per week, or $10 per month for a tent. Wooden floors and electric lights were included in the price. Because of prohibition, the $250,000 Hotel Redondo closed its doors and in 1925 was sold for scrap lumber.

REDONDO BEACH PLUNGE—The Redondo Beach Plunge, billed as the "largest indoor salt-water-heated pool in the world," was built in 1909 by Henry Edward Huntington. Four stories high and Moorish in style, it housed three pools heated by Pacific Light and Power's steam plant (originally built to generate electricity for the Red Cars). A tower, two diving boards and a trapeze were features of the large main pool. It was located on the beach, between the ends of the Horseshoe Pier, where a parking structure stands today.

One of the popular tourist attractions was the Redondo Beach Lightning Racer roller coaster, which had two parallel tracks. In cars traveling more than six thousand feet of track, riders had the sensation of racing those in the adjoining car. First opened to the public in 1913, the Lightning Racer was located on the beach just north of old Wharf 1 (and today's Municipal Pier). Severely damaged by an extreme storm in March 1915, the coaster was demolished.

Other Redondo Beach attractions adjacent to the Plunge included the Casino and Dance Pavilion/Auditorium. The first pavilion would be replaced by a grander pavilion in 1907.

The natural salt lake was located near Redondo Beach's northern border with Hermosa Beach, in the area where the AES Redondo Beach Generating

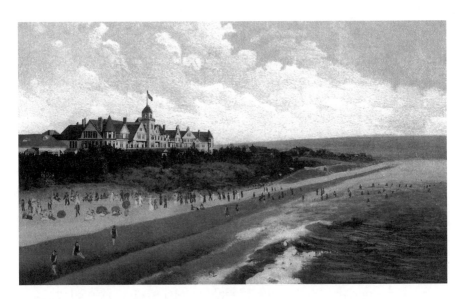

Hotel Redondo postcard. *Courtesy Marilyn Ron Collection.*

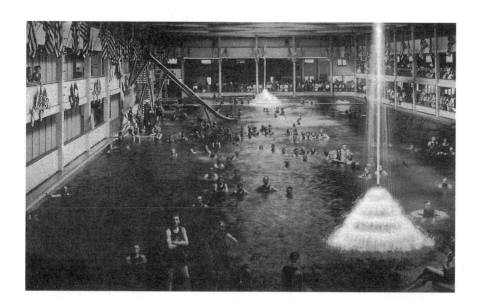

This page: Redondo Beach Plunge postcards. *Courtesy Marilyn Ron Collection.*

Station now stands. The spring-fed salt lake, about two hundred yards wide and six hundred yards long, was located about two hundred yards inland from the ocean. Salt was mined from 1854 to 1881.

The Rex Gambling Ship

Big-time gambling, complete with mobsters and shooting incidents, found its way to Redondo Beach during the Depression. Chip games, bingo parlors and a casino were run in full view of the law between 1936 and 1939. For a fare of twenty-five cents, a water-taxi would transport a visitor to the gambling ship *Rex*, which operated three miles offshore.

The *Rex* was operated by a colorful character named Tony Cornero. Tony was a rumrunner during prohibition and began his gambling career by building the Meadows, one of the first hotel/casino operations in Las Vegas in the early 1930s, near the intersection of Fremont Street and Charleston Boulevard. The hotel only had thirty rooms, and Tony only owned the casino for a few years. Many people believe that the Flamingo Hotel, built by Bugsy Siegel, was the first Las Vegas casino, but it was not built until 1945.

After selling the Meadows casino in 1932, Tony outfitted a ship called the *Rex* for about $200,000 for offshore gambling and anchored it just past the three-mile limit off Redondo Beach. Games available included roulette, blackjack, poker and craps. It had three hundred slot machines on board and a bingo parlor that seated five hundred players. While operating between May and December 1938, Cornero claimed that the *Rex* brought in $500,000 per month and profits of more than $200,000 per month. Although gambling was not a federal crime, local and state authorities were outraged.

Boatloads of officials tried to board the *Rex*, but Cornero's crew bluffed them away, sometimes by aiming fire hoses. Cornero's brother, Frank, was even charged with kidnapping an investigator from the district attorney's office, although the charge was later dismissed by a judge, who ruled that there was insufficient evidence that the investigator had been forced to board the *Rex*. Eventually, Los Angeles County deputies were able to board the ship. The sheriff brought photographers to capture the deputies taking axes to roulette wheels and hurling craps tables overboard.

Extensive litigation with the State of California followed, with Earl Warren, California Supreme Court chief justice, vowing to shut the

gambling ships down. Finally, the federal government decided that while the gambling was not illegal, the ships would hamper preparations for a possible conflict in the Pacific. The Coast Guard seized the *Rex* in November 1939. Eventually, Tony would raise money from investors and constructed the Stardust Hotel in Las Vegas in 1955, but he died at the gambling tables of the Desert Inn from a heart attack before the completion of the Stardust.

History of King Harbor

In September 1938, a bond issue was passed that called for construction of a 1,485-foot breakwater north of the Redondo Beach pleasure pier to construct a boat harbor with the assistance of the Works Progress Administration (WPA).

The proposed breakwater was started in 1939 but only partially finished. The short breakwater changed the flow of the current along the shoreline, resulting in extensive beach erosion and the destruction of shoreline homes. The north beach area suffered several seasons of heavy damage, and residents called for the removal of the inadequate breakwater.

The onset of World War II resulted in a freeze on all federal funds except for high-priority projects for the war effort. Of course, Redondo's boat harbor did not fall into this category, so the completion of the breakwater would have to wait until peacetime. After World War II, construction began on an improved breakwater that used 100,000 tons of rock to protect the area from winter storms; this temporary breakwater was completed in 1947.

Another storm in 1953 again damaged the breakwater, city streets and shoreline homes. A group of Redondo citizens appealed to Representative Cecil R. King (Democrat, Seventeenth District) for help in developing a proper boat harbor, one that would lend itself well to recreational tourism. In 1956, the federal government authorized $45 million, and work began on the marina that exists today, named King Harbor in honor of the congressman. The breakwater was completed in 1958. Harbor bonds totaling $9 million were approved in 1959 to finance the inner-harbor construction project, and by 1963, the first boat slips were available in King Harbor. The plan for the inner-harbor construction project included 1,450 boat slips, utilities, a swimming facility (today's Seaside Lagoon) and several parking lots. This investment was immediately followed by an additional $15 million contributed by

the five original lessees. Due to high demand from the beginning, the boat slips were given first priority, and many were occupied while other facilities were still under construction.

This provided an important source of revenue during the building of the harbor. King Harbor was dedicated in 1966. Its boating basins consist of four marinas, two yacht clubs and a hotel complex.

Unlike most marinas (including Marina Del Rey), which are fully contained within inland basins, King Harbor is situated completely seaward of the existing shoreline. This occasionally subjects it to severe weather and ocean conditions, the same problems that faced the original port of Redondo Beach in 1887. After King Harbor was severely damaged by storms in the winters of 1962 and 1963, the U.S. Army Corps of Engineers made additional breakwater improvements in 1967 to increase protection and reduce the chance of future storm damage. Severe storms in 1980, 1983 and 1988 overtopped and damaged the breakwater again, and the Army Corps of Engineers made repairs in 1992 and 1998.

The Los Angeles and South Bay Red Car Line

Henry Huntington was a very major real estate developer and public utility system tycoon in southern California. In 1901, Huntington formed the Pacific Electric Railway ("PE") to serve his real estate development aims in the Los Angeles area. The largest of the suburban electric railways operating out of downtown Los Angeles in the early 1900s was not Huntington's Pacific Electric, though, but rather the Los Angeles Pacific ("LAP"). The heads of LAP also had extensive real estate development projects in Hermosa Beach, Manhattan Beach, Playa del Rey and Hollywood.

This very extensive railway ran streetcar lines out through Hollywood and suburban trolley lines to Santa Monica, Brentwood and down the coast to Redondo Beach in what was called the "balloon route."

In 1906 Edward Harriman, head of the Southern Pacific (SP) Railroad, gained control of the Los Angeles Pacific. In 1910, he finally acquired Huntington's PE, and in 1911, he merged the two into Pacific Electric. At that time, all of the transit cars were painted red, leading to the moniker "Red Car line."

The line to Redondo Beach via Playa del Rey was one of two electric railway lines to the beach operated by PE prior to World War II, the

Red Car line on the Strand in Manhattan Beach. *Courtesy Manhattan Beach Historical Society.*

other running from Los Angeles through Gardena and Torrance. The route that had the higher ridership in the '30s was the more scenic route down the coast from Playa del Rey. This route led along the ocean from Playa del Rey through Manhattan Beach before veering inland a bit through Hermosa Beach and ending in Redondo Beach. The developers of Palos Verdes in the early 1920s planned for the extension of the Red Car line into the Peninsula and provided wide median strips in Valmonte and Lunada Bay to accommodate the lines.

One of the major problems with PE as a passenger railway was that when developers originally invested in the trolley lines to serve their subdivisions, they were interested in providing only the minimum facilities they needed in order to sell real estate; they were not intended to make money providing passenger service. In fact, the PE passenger operations as a whole never made a profit. The Southern Pacific was willing to accept the perennial operating losses of PE because SP made quite a bit of money off the freight business that was fed to SP by PE. In the era between the '20s and the '50s, PE was the main hauler of freight to and from the combined ports of Long Beach and Los Angeles.

The Red Car line also could never be called "rapid transit," as it had to slog its way through surface street traffic. It was also very overcrowded. The trip from downtown Los Angeles to Redondo Beach took well over an hour. The increased ownership and convenience of the automobile spelled the demise of the Red Car. The line suffered severe operating

losses throughout the 1930s and was slowly replaced by bus service through the 1940s. The Redondo Beach line was eliminated in 1940. The Red Car line is now only a nostalgic memory.

Other South Bay History Tales

Machado Lake

Machado Lake is located in the Ken Malloy Harbor Regional Park, bounded by Anaheim Street, South Vermont Street, Pacific Coast Highway and the 110 Freeway in Harbor City. The regional park, at 241 acres, probably contains the greatest biodiversity of any like-sized site in Los Angeles County—certainly in the coastal section of the county.

The lake was named for Antonio Machado, who had married the widow of Jose Dolores Sepulveda (who first laid claim to Rancho de los Palos Verdes in a dispute with the Dominquez family over rights over part of Rancho San Pedro in the early 1800s) shortly after Jose died in 1824. Historians suspect that the subsequent union of Machado and Sepulveda's widow came about so she would have a husband to protect the Sepulveda family's claim to the land and the lake that later bore Machado's name.

Machado lived where the golf course sits today. Juan Capistrano Sepulveda, stepson of Antonio Machado and one of two sons of Jose Dolores Sepulveda, built his adobe home near the intersection known as "Five Points" in San Pedro, which is the convergence of the following five streets: Palos Verdes Drive North, Gaffey Street, Anaheim Street, Vermont Avenue and Normandie Avenue. The casa was located on the bluff on the northwest side of this intersection, possibly the site of the trailer park, and the casa overlooked Machado Lake.

The lake is generally considered to have been an "oxbow" (or "bend in a river") running from the Los Angeles River's location at some point in the past. It was tidal at some point as well. Many effects are still present, such as beach sand and "sea shells" in some areas. Going back to the earliest of known times, it was a center of American Indian habitization locally, with several villages around it over the years. The water at Machado Lake was so clean that it used to be called "Sweet Water." When the Spaniards invaded from Mexico and enslaved the American Indians, it remained at the center of activity, with trading posts (the "Casa de Sangre" at Five Points) and more around it.

Machado Lake. *Photo by Bruce Megowan.*

The riparian willow forest around the lake was named Canada de los Palos Verdes in the mid-1600s by the explorer Sebastian Vizcaino. The site was known as Bixby Slough for some time when owned by the Bixby family of Long Beach in the late 1800s (a sign on PCH at the Wilmington Drain still calls it such). For many years, Lake Machado and the aquifer surrounding the lake were the primary sources of drinking water for the Palos Verdes Peninsula once development began in the early 1920s.

The City of Los Angeles purchased the lake in the 1950s to preserve it as open space in the big city. It was officially developed into a park in the very late 1960s. That was when the lawns and facilities were put in on the west side of the lake along Vermont Avenue. Beginning in March 2014, the park began a three-year $111 million habitat restoration project that will dredge the lake and remove contaminants. The park will be closed during this period.

Madrona Marsh

The Madrona Marsh Nature Preserve, located just east of Del Amo Fashion Center and bounded on the north and south by Plaza del Amo and Sepulveda Boulevard and east and west by Maple and Madrona Avenues, is considered

to be the last remaining vernal marsh in Los Angeles County. Vernal marshes are found in low-lying areas where rainfall runoff accumulates.

The marsh preserve is a remnant of once extensive natural systems that existed along the coastal plain and coastal terraces of Southern California. The preserve is situated on land that has been in oil production since 1924. This is why it was never initially developed for commercial or residential uses.

In the early 1960s, this area had been included as a proposed site for a new state college that eventually became Cal State Dominquez Hills. In 1964, this area was then proposed for a Torrance municipal golf course, but this was never pursued due to high cost estimates to acquire the land.

In 1972, Torrance Investment Company, a firm consisting of developers Ray Watt, Guilford Glazer and Shurl Curci, proposed developing the whole parcel for homes, condominiums and office space. The group Friends of the Madrona Marsh was formed in 1972, and together with another group, Stop Torrance Overdevelopment Plans (STOP), they opposed the development proposals. Negotiations with environmentalists, debates and environmental impact reports continued throughout the 1970s. In 1980, the developers offered 15.0 acres for preservation. In 1983, they came up with an offer that eventually would be accepted: 34.4 acres would be deeded to the city, with another 8.5 acres made available for sale. The developers used the land to develop the Park del Amo condominium project.

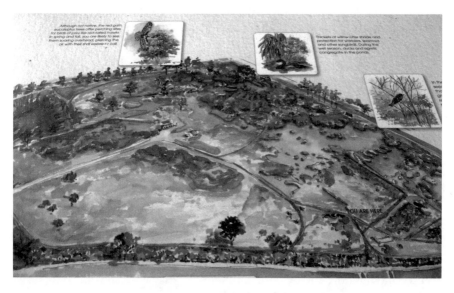

Map of Madrona Marsh. *Photo by Bruce Megowan.*

Madrona Marsh. *Photo by Bruce Megowan.*

In 1984, Torrance was given a deed to the marsh, but it would be two more years until the arrangement would become formalized. The city finally won clear title to the land on September 16, 1986.

Over the years, the marsh began to take shape as a nature preserve. Tons of truckloads of trash and other dumped debris were hauled away in 1989, and in 1994, two hundred tons of inactive oil drilling pipes on the property were dug up and removed.

The eight-thousand-square-foot Madrona Marsh Nature Center, located across from the marsh at 3201 Plaza del Amo, opened on Saturday, April 28, 2001. The $1.8 million project was a joint venture of the Friends of the Madrona Marsh and the City of Torrance, using funds from Proposition A, which passed in 1996. Activities include bird and nature walks, natural history classes and workshops, habitat restoration, science and astronomy programs, art exhibits and children's nature programs.

In recent years, Madrona Marsh has been closed for temporary periods over concerns about mosquito larvae found there. The marsh, however, remains as a precious preserve for plant life and animals and a wonderful resource to teach our children about nature.

Catalina Island and the Chicago Cubs

Chewing gum magnate William Wrigley Jr. purchased Catalina Island in 1919 and shortly thereafter, in 1921, gained a controlling interest in the Chicago Cubs in 1921. He then became the first baseball owner to bring a major-league club out west for spring training, building a facility for the Cubs on Catalina in 1921 that he called Wrigley Field.

It was the first baseball facility to bear Wrigley's name. It opened up earlier than the minor-league Los Angeles Angels' baseball facility of the same name, which Wrigley built in 1925 in South Los Angeles. Coincidentally, one of the streets bordering this ballpark was named Avalon, the location of Wrigley's Catalina facility. The more famous Chicago ballpark was known first as Weeghman Park and then as Cubs Park, before being renamed Wrigley Field in 1926. The Catalina Wrigley Field's dimensions were built identical to those of the major-league club's Chicago home field.

Only a plaque noting the location remains now on the grounds of what is currently the Catalina Island Country Club, although its clubhouse is the same structure that Wrigley built for the Cubs. The locker room for the country club is the same locker room used by the Cubs during their spring training visit.

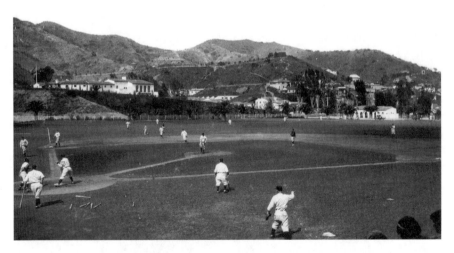

Chicago Cubs at Catalina during spring training. Note the Catalina Country Club in the upper-left background. *Courtesy Permanent Collection of the Catalina Island Museum.*

The Cubs trained on Catalina every spring from 1921 to 1941 and from 1946 to 1951. (The island was controlled by the U.S. military during the war years.) An amazing array of baseball stars spent their springs in the bucolic setting, including Charlie Root, Phil Cavaretta, Charlie Grimm and Hall of Famers Rogers Hornsby, Dizzy Dean, Gabby Hartnett, Joe McCarthy, Grover Cleveland Alexander and Hack Wilson.

The team would arrive every spring on one of Wrigley's fleet of ships used for transportation from the mainland. These included the *Hermosa*, the *Cabrillo*, the SS *Avalon* and, beginning in 1924, the SS *Catalina*, the "Great White Steamship." After disembarking, the team would join the fashionable set and stay at the island's fanciest hotel, the Hotel St. Catherine on Descanso Bay.

The club would spend most of the spring playing intra-squad games, although occasionally outside teams such as the Pacific Coast League's Los Angeles Angels would make the trip over for some games. The Cubs would also make the trip to the mainland right after spring training for exhibition games with West Coast minor-league teams. The team's home games were free, and the stadium was a major tourist attraction on the island during spring training.

The Cubs' last season on the island was 1951. A spell of bad weather, including a snowstorm, may have played a role in convincing the team to move spring operations to Mesa, Arizona.

History of the City of Lomita

The earliest known inhabitants of the area now part of the city of Lomita were the Gabrielino Indians in a village they called Suangna ("Place of the Rushes"), near what is now the intersection of 230th Street and Utility Way in Carson. This land was originally a small part of the Spanish land grant called Rancho San Pedro, given to Juan Jose Dominguez in 1784. Jose Dolores Sepulveda had grazed cattle in the area below the Palos Verdes Peninsula since 1809 and had many ongoing disputes with the Dominquez family over Sepulveda's claim to a large portion of the Rancho San Pedro. During the period from 1865 to 1880, the Sepulvedas were engaged in seventy-eight lawsuits, six land partitions suits and twelve suits over eviction of squatters.

At the conclusion of these complicated lawsuits on September 25, 1882, Rancho de los Palos Verdes was partitioned into seventeen portions. The

largest share, the 17,085 acres that constituted the Palos Verdes Peninsula, was awarded to Jotham Bixby, with only about 4,411 acres (most of the town of San Pedro) awarded to the family of Sepulveda. Nathaniel Andrew Narbonne and his partner Ben Weston received 3,574 acres that constitute most of present-day Lomita.

Narbonne had moved to Lomita from Sacramento's gold rush country in 1852. He had initially worked with General Phineas Banning in Wilmington, and later, with partner Ben Weston, he grew wheat and raised sheep on Santa Catalina Island.

Lomita gets its name for the Spanish word for "little hills." Development in Lomita began in earnest in the period between 1901 and 1909. In 1907, the W.I. Hollingsworth Company purchased a large tract of land just north of the Palos Verdes hills. The company intended to make the seven-square-mile subdivision a Dunkard colony after several of its clients, who were Dunkards, had expressed an interest in founding a settlement in the Los Angeles area.

In 1923, oil was discovered in the Lomita area. About five hundred acres of land in Lomita were used for drilling for oil. Property values skyrocketed. Lots that had originally been purchased for $300 to $400 sold for as much as $35,000. In the 1930s, the predominant land use was for farming of celery and strawberries. Development boomed immediately after the end of World War II.

By the early 1960s, all but about 1.9 square miles of the 7.0 square miles of the original development of Lomita had been annexed by the adjacent city of Torrance. After several unsuccessful attempts, the city of Lomita was incorporated on June 30, 1964. Lomita is served by the Los Angeles Unified School District. In 1989, 1993 and 1999, the citizens of Lomita attempted to secede from the Los Angeles Unified School District but were unsuccessful.

South Bay Freeways

Many South Bay residents wonder why another freeway spur was never built into the South Bay for easier access for residents to the freeways. In 1941, right after the beginning of World War II, a proposal received serious consideration to build a motor expressway from the San Fernando Valley to the base of the Palos Verdes Peninsula. This was proposed for civil defense purposes but obviously was never constructed.

The original 1946 master plan for the Southern California freeway system included what was known as the Ocean Freeway/Pacific Coast Freeway, which was to have run along the coast, swinging inland through Redondo Beach and Torrance, connecting to the Harbor Freeway and extending through Long Beach. This also included a spur called the Manhattan Beach Parkway that would have connected the Ocean Freeway to the San Diego Freeway (it would have run from the Ocean Freeway (which at that time was Vista Del Mar) to the San Diego Freeway, roughly along Marine Valley Drive, and would have cut across what is now the Los Angeles Air Force Base), as well as a connector to the Artesia Freeway (now the 91 freeway).

This proposed freeway, of course, created a huge uproar, especially in Manhattan Beach, where the freeway was planned to run near Sepulveda Boulevard, splitting the community in half.

Another freeway connecting to the San Diego Freeway, roughly following to the east of Hawthorne Boulevard, had also been proposed. In 1968, several alternative alignments of what was called the "Hawthorne Freeway" (Route 107) were considered. These included routes connecting from the San Diego Freeway roughly following just to the east of Inglewood Boulevard and as far west as Prospect through Manhattan Beach and Redondo Beach, then swinging east along the Palos Verdes Peninsula foothills and terminating at Vermont Avenue (with a planned connection with the Harbor Freeway when the Ocean Freeway was to be extended through Long Beach).

The southernmost route considered would have demolished some homes in Rolling Hills Estates, in the neighborhoods of Montecito and Empty Saddle and the Empty Saddle Club. Due to funding constraints and neighborhood opposition, these freeways were never constructed.

Construction of the Harbor Freeway began in 1954 and was completed in 1962. The portion from I-10 south to Pacific Coast Highway (SR-1) was originally labeled as US 6 and SR-11. In 1963, US 6 was removed, and in 1984, SR-11 was renumbered as I-110. Construction of the 405 freeway began in 1957, with completion of the first section north of LAX completed in 1961. The next section south to the 605 freeway was finished within a few years thereafter.

Louis Zamperini

Louis ("Louie") Zamperini is one of the greatest South Bay heroes who ever lived. Zamperini was born January 26, 1917, in Olean, New York, to Italian immigrants Anthony Zamperini and Louise Dossi. In 1919, the family moved to Torrance. Louie had a troubled childhood, and it is said that he developed his extraordinary athletic talents from outrunning the local police.

Louie attended Torrance High. To counter Louie's tendency to get into trouble, his older brother, Pete, encouraged Louie to join the track team. He excelled in the long-distance events and in 1934 set a world interscholastic record for the mile, clocking in at 04:21.2. This earned him a scholarship to the University of Southern California.

Louie's specialty was the mile run, but for the 1936 Olympics, he trained for the 5,000 meters, believing that he had a better chance at that distance, and qualified for the team. Although he finished eighth in the 5,000 meters at the Olympics, his finishing lap of 56 seconds drew the attention of Adolf Hitler, who specifically asked to meet the young man. Louie later managed to steal a Nazi flag as a souvenir. Louie finished off his running career by setting a national collegiate mile record of 4:08 in 1938 that held for fifteen years, earning him the nickname "Torrance Tornado." At the time, many believed that Louie would be the first to break the four-minute-mile barrier.

Louie joined the U.S. Army Air Corps in September 1941 as a second lieutenant flying a B-24 bomber in the Pacific. He and two other crewmen were shot down during a rescue mission searching for another downed bomber and spent forty-seven days adrift in the Pacific Ocean. After reaching the Marshall Islands, he was immediately captured by the Japanese. Zamperini was held in the Japanese prisoner of war camp at Ōfuna for captives who were not registered as POWs. Louie was held prisoner with Gregory "Pappy" Boyington of the famed "Black Sheep Squadron" and became friends. One of the guards there, James Sasaki, had known Louie at USC. Louie was especially tormented by another sadistic prison guard, Mutsuhiro Watanabe (nicknamed "The Bird").

After the war, Louie found the means to forgive his tormentor after attending a Billy Graham Crusade and began a career as an inspirational Christian speaker.

Zamperini had been reported lost at sea, and his family believed him to be dead. The City of Torrance in 1944 renamed the Torrance Airport as Zamperini Memorial Field. After the war ended and Louie was released

from prison camp, on December 7, 1946, the city named the airstrip at Torrance Municipal Airport Zamperini Field, but unfortunately, this name change was never officially recognized. Finally, on January 29, 1974, the Torrance City Council made the name change official. In 1987, the football field at Torrance High was renamed Zamperini Field.

Zamperini's life has now been documented in a new movie based on the best-selling book *Unbroken*, currently being filmed and directed by Angelina Jolie.

BIBLIOGRAPHY

Books

Christy, Don, and Vicki Mack. *Up Around the Bend: Stories and Legends in Palos Verdes' Portuguese Bend.* Palos Verdes Estates, CA: Pinale Press, 2012.

Clark, Ginger Garnett. *Images of America: Rancho Palos Verdes*. Charleston, SC: Arcadia Publishing, 2009.

Dennis, Jan. *Images of America: Manhattan Beach Pier*. Charleston, SC: Arcadia Publishing, 2005.

Fink, Augusta. *Palos Verdes Peninsula: Time and the Terraced Land*. Lafayette, CA: Great West Books, 2004.

Hansen, A.E. *Rolling Hills: The Early Years*. Rolling Hills, CA: Typecraft, 1978.

Hazard, Mary Jo. *The Peacocks of Palos Verdes*. Los Angeles, CA: Donegal Publishing, 2010.

Mack, Vicki. *Frank A. Vanderlip: The Banker Who Changed America*. Charleston, SC: CreateSpace, 2013.

Morgan, Delane. *The Palos Verdes Story*. Palos Verdes Estates, CA: Review Publications, 1982.

Niiya, Brian, ed. *Japanese American History: An A-to-Z Reference from 1868 to the Present*. New York: Facts on File, 1993.

Phillips, John. *Images of America: Palos Verdes Estates*. Charleston, SC: Arcadia Publishing, 2010.

Vanderlip, Elin. *Eccentric, Obstinate and Fabulous!* Los Angeles, CA: Donegal Publishing, 2008.

Websites, Articles and Other References

California Highways. http://www.cahighways.org/maps-sc-fwy.html.

California State Military. "Drum Barracks." http://www.militarymuseum.org/DrumBks.html.

City of El Segundo. http://www.elsegundo.org/working/history/default.asp.

City of Hermosa Beach. http://www.hermosabch.org/index.aspx?page=42.

City of Lomita. "History." http://www.lomita.com/cityhall/about/history.

City of Rancho Palos Verdes. "City History." http://www.palosverdes.com/rpv/news/content/City_history.cfm.

———. Community Forum, Summer 2002. http://www.palosverdes.com/rpv/news/newsletters/2002/2002Summer.

City of Redondo Beach. "History of Redonda Beach." http://www.redondo.org/in_the_city/history.

City of Redondo Beach, California. "By-Gone Landmarks." http://home.earthlink.net/~beckers912/presprog/by-gone.htm.

The City of Rolling Hills Estates, California. "History of Rolling Hills Estates." http://www.ci.rolling-hills-estates.ca.us/index.aspx?page=59.

Claire, Rosemary, and Jim Kinney. "History of the Palos Verdes Schools." *Daily Breeze,* January, 29, 2006, A4.

Daily Breeze. "Palos Verdes Research Park." December 31, 2006, A4.

Dominquez Ranch Adobe Museum. http://dominguezrancho.org/history.

Friends of Madrona Marsh. http://www.friendsofmadronamarsh.com/j/index.php?option=com_content&view=category&layout=blog&id=34&Itemid=53.

Gates, Thomas. "The Palos Verdes Ranch Project." Kent State University. http://corbu2.caed.kent.edu/architronic/v6n1/v6n1.03a.html#ref1.

Gnerre, Sam. "History Blog by Sam Gnerre." http://blogs.dailybreeze.com/history.

Hermosa Beach Chamber of Commerce. http://www.hbchamber.net/history.htm.

Hermosa Beach Historical Society. http://www.hermosabeachhistoricalsociety.org.

Hermosa Beach Neighborhood Association. http://www.hbneighborhood.org/HBhistory1.htm.

Image Archeology. "Marineland of the Pacific." http://www.image-archeology.com/marineland_of_the_pacific_CA.htm.

Jankowiak, William R. "Historical Perspective Rancho San Pedro to Lot 49—Section 7 Ownership & Land Use," 1977. Located in the local history room of the Palos Verdes Library.

Kano, Denise. "Clifford Reid and the Hollywood Riviera—Shooting for the Stars." *South Bay Digs Magazine,* n.d.

———. "The Timeless Charm of the La Venta Inn." *South Bay Digs Magazine*, October 28, 2011.

Ken Malloy Harbor Regional Park. http://www.utopianature.com/kmhrp/whatis.html.

King Harbor. http://kingharbor.com/about.

La Venta Inn. "History." http://www.laventa.com/history.

Los Angeles Almanac. "The Era of the Gambling Ships and the Battle of Santa Monica Bay." http://www.laalmanac.com/history/hi06ee.htm.

Louis Zamperini. "Biography." http://www.louiszamperini.net/?page=bio.

Manhattan Beach Historical Society. http://www.manhattanbeachhistorical.org/history.

Marineland of the Pacific. http://www.marinelandofthepacific.org/pages/1.

Melilios, Melissa. "Marineland's History Is a Roller Coaster." *Daily Breeze*. Available at Whale-Web Forums. http://forums.whale-web.com/showflat.php?Cat=&Number=131796&Main=131796.

National Park Service. "A History of Japanese Americans in California." http://www.cr.nps.gov/history/online_books/5views/5views4h101.htm.

Palos Verdes Public Library. Numerous files of newspaper clippings maintained in the Local History Room.

Palos Verdes Research Park. http://www.smecc.org/palos_verdes_research_park.htm.

Rasmussen, Cecelia. *Los Angeles Times*, July 25, 2004. Available at http://listsearches.rootsweb.com/th/read/BERENDO/2004-07/1090811711.

Redondo Beach Historical Society. http://www.redondohistorical.org/?page_id=78.

Redondo Riviera Real Estate. http://www.redondoriviera.com/history.html.

Rootsweb. "Dr. Seuss and Ted Geisel." http://listsearches.rootsweb.com/th/read/BERENDO/2004-07/1090811711.

San Francisco Call. "E.G. Lewis Indicted for Mail Frauds." July 13, 1911. http://cdnc.ucr.edu/cgi-bin/cdnc?a=d&d=SFC19110713.2.26.

Spring Training History. http://springtrainingmagazine.com/history2.html.

Thacker, Mary Eva. "A History of Los Palos Verdes Rancho, 1542–1923." Located in the local history room of the Palos Verdes Library.

Torrance Historical Society. "Research." http://torrancehistoricalsociety.org/research.

University City, Missouri. "University City History." http://www.ucitymo.org/index.aspx?NID=15.

Water and Power Associates. http://waterandpower.org/museum/California_Historical_Landmarks_Listing_LA_Page_1.html.

Wayfarers Chapel. http://www.wayfarerschapel.org/wayfarers/w_history.html.

Wikipedia. "Edward Gardner Lewis." http://en.wikipedia.org/wiki/Edward_Gardner_Lewis.

———. "Fort MacArthur." http://en.wikipedia.org/wiki/Fort_MacArthur.

———. "Korean Bell of Friendship." http://en.wikipedia.org/wiki/Korean_Bell_of_Friendship.

ABOUT THE AUTHORS

BRUCE MEGOWAN has been in the commercial and residential real estate business since 1972. He began his career after graduating from the University of Southern California in 1972 with a Bachelor of Science in accounting and spent the next nine years as a CPA with Touche Ross & Company, serving real estate clients. During that time, he earned an MBA in real estate finance, also from USC, and became a licensed real estate broker. For the next twenty years, Bruce served as a senior executive for several large real estate development companies and pension fund realty advisors. Bruce currently acts as an independent real estate broker and an amateur local historian.

MAUREEN MEGOWAN began her real estate career in 2003. Becoming a Realtor was a natural extension of her previous careers as a fashion designer, working in merchandising and sales to department and specialty stores nationwide and later, as an interior and home improvement consultant. Maureen has a Bachelor of Science in clothing and textiles from California State University–Chico, as well as a degree

in fashion design and merchandising from the Fashion Institute of Design & Merchandising. Maureen has a unique ability to help sellers prepare their property for sale, whether by simply staging the home or monitoring more extensive home improvements. Maureen is also a lover of history, especially local history. She is a member of the Daughters of the American Revolution.

Bruce and Maureen have lived in the South Bay for forty years and in the Lunada Bay area of Palos Verdes Estates for the last thirty years, where they have raised three sons. They share a love for the South Bay and the Palos Verdes Peninsula and believe that it is truly one of the best places in the world to live and raise a family.